IMAGES
of America

BROOKLAND

D1450691

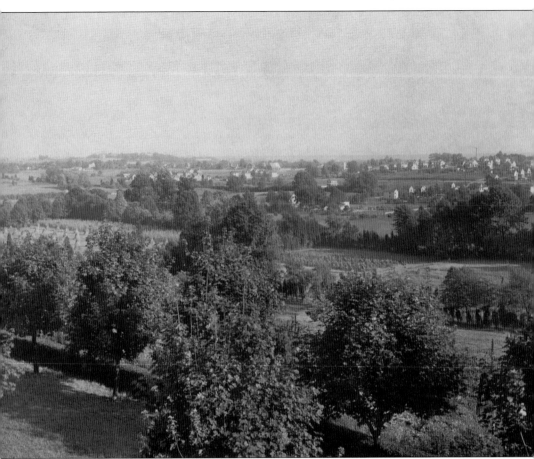

Early suburban development of Brookland happened slowly. From the first platting of subdivisions in the 1920s, the central neighborhood had many empty lots. This is a 1900 southerly view of the village of Brookland, from the Franciscan Monastery, looking toward Monroe Street. This view includes what would later become the Lourdes Grotto in the foreground. (Franciscan Monastery.)

On the Cover: A large crowd stands in Brookland's main street in June 1938, gathered for the cornerstone laying of the new St. Anthony's Roman Catholic Church, located at Twelfth and Monroe Streets. In this sea of faces are people who remember when Brookland was only a few houses scattered out among fields. There are people in this crowd who will live to see an urban neighborhood around a Metro station 40 years later. (St. Anthony's Roman Catholic Church.)

IMAGES
of America

BROOKLAND

John J. Feeley Jr.
and Rosie Dempsey

ARCADIA
PUBLISHING

Published by Arcadia Publishing
Charleston, South Carolina

Printed in the United States of America

Library of Congress Control Number: 2011922230

For all general information, please contact Arcadia Publishing:
Telephone 843-853-2070
Fax 843-853-0044
E-mail sales@arcadiapublishing.com
For customer service and orders:
Toll-Free 1-888-313-2665

Visit us on the Internet at www.arcadiapublishing.com

To the memory my mother, Marianne Kerins Dempsey, who spent her early married life seven blocks from where I make my home today.

—Rosie Dempse

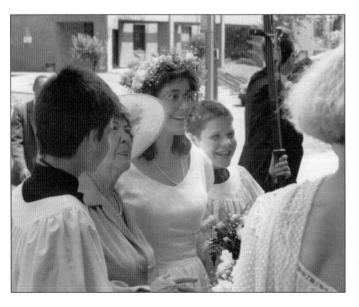

To the memory of my late wife, a true lover of our neighborhood, Helen D. Young—shown here on our wedding day beside her mother, Helen Kerins Young. (Courtesy of John J. Feeley Jr., photograph by Gregory Addison.)

CONTENTS

ACKNOWLEDGMENTS

We are grateful to Brookland residents and friends and the professionals who assisted us in this project, including Cookie Armstrong; Bijan C. Bayne; Cathryn Barnsdale; Elizabeth Bray, our editor; Anna Brinley; Brooks descendants John Cahill, Mary Kindrat, Molly Murray, Peter Murray, and JoAnn Sneider; Fr. Frederick Close; Carlton Crudup; Donald Davidson; Laura Henley Dean; Paul Dickson; Thomas Diggs; archivist JoEllen El Bashier; Gayle Fisher-Stewart; Elizabeth Fleming; archivist John Gartrell; Lieutenant Glaze; Elizabeth Goldberg; Donald Harrell; archivist Faye Haskins; Linda Harper; historian Sister Mary Hayes; Jeffrey Heynan; Father Jeremy; archivist Karen Levenback; Bob Malesky; Peggy O'Brien; archivist Robin Pike; Rohulamin Quander; C. Akia Quanderjordan; Phil Raidt; Laura Saylor; Susan Scheid; Leon Seeman; the Senerchias: Anthony, Martha, Michael, Noelle and Susie; Rita Smith; Jim Stiegman; Trisha Wolfbauer; Lavinia Wohlfarth; Bruce Yarnall; and Nell Ziehl.

Archival collections featured include the Afro-American Newspaper Archives and Research Center (AAA); the Catholic University of America Archives (CUAA); DC Public Library, the Washingtoniana Division, Star Collection © *Washington Post*, and DC Community Archives Steinberg Collection (DCPLW); Franciscan Monastery (FMA); the George Washington University Libraries, Special Collections Research Center, courtesy of George W. McDaniel, (GWA-GM); Historical Society of Washington (HSKL); Howard University Archives (HUA); Library of Congress (LOC); National Archives & Records Administration (NARA); St. Anthony's Roman Catholic Church (SAA); Charles Sumner School Museum and Archives (SSMA), courtesy of Hayden Wetzel, who did extensive research; and, Trinity Washington University Archives (TUA). Photographs without attribution came from the authors' collections.

Demolished buildings are identified with **. Sites on Cultural Tourism DC's African American Heritage Trail are identified with ++.

This project was supported in part by Cultural Tourism DC. We are indebted to *Images of Brookland* (1988, edited by George W. McDaniel, John N. Pearce, Martin Aurand) and Laura Henley Dean's 1993 CUA dissertation "Past Before Us: An Examination of the pre-1880 Cultural and Natural Landscape of Washing County, DC" and Dean and Robert Verry's "Report of Results of the Brookland Community, CUA Historic Resources Survey."

To share your item of Brookland history, or see errata and book events, please visit www. BrooklandDChistory.com.

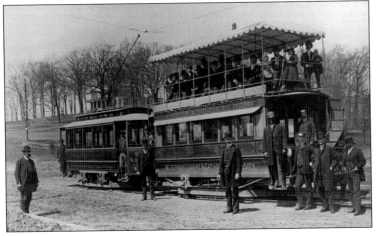

An 1889 trolley is shown at its last stop on Fourth Street and Bunker Hill Road (today's Michigan Avenue). (DCPLW.)

INTRODUCTION

Brookland is a vibrant urban neighborhood with clear physical links to its rural past. It grew from a village into the preeminent Northeast suburb of Washington, DC. Brookland has a legacy of racial integration, and historic associations with area universities and religious institutions. Its residents, white and black, have made a mark on the nation's history. Many families in the metropolitan area trace their roots back to Brookland.

If Colonel Brooks had succeeded in his 1870s fight to keep the B&O Railroad from crossing his property, Brookland might never have become the transportation hub it is today. Instead, in 2012, it will celebrate its 125th anniversary.

Since its beginning, Brookland's identity and boundaries have expanded and contracted. What became Brookland was originally part of Washington County, and so in the first chapter, we describe the broad context out of which it developed. This geographic area included what were Native American hunting grounds, farms, country estates, and military fortifications. In its early development, Brookland included the territory of many later neighborhoods—Woodridge, Michigan Park, Edgewood, and Brentwood. As we consider Brookland from the 1930s onward, the boundaries contract to those determined by civic organizations: north of Rhode Island Avenue, east of the B&O Railroad tracks (or just a few blocks over), west of Eighteenth Street and South Dakota Avenue, and south of Michigan Avenue. Today, as realtors consider Brookland, its boundaries again seem to be broadening.

Brookland as a new trolley suburb is discussed in chapter two. Housing lot sales began at a slow pace in those early years, with only a few homes on many blocks surrounded by fields of tall grass. Nonetheless, during this period when Brookland was a small village, residents developed a strong community identity. Fortunately, many of the first community buildings are still with us: the old Brookland School (now Luke C. Moore Academy), Engine Company No. 17 (then called Chemical Company No. 4), and the Masonic hall—all within a block of each other. Institutional properties, such as the Franciscan Monastery and Howard University's Divinity School, have played an important role in preserving large tracts of open land.

In chapter three we consider the development of the commercial strip. In 1925, when the trolley line expanded to turn at Twelfth and Monroe Streets, many shops had already been built. When the streets were paved two years later, Brookland's main street was transformed into a busy thoroughfare. Trolley and bus service turned Brookland into a transportation hub, and encouraged its growth. The Catholic University of America (CUA) and Trinity College acted as significant anchors, and numerous religious orders built here and stayed.

The list of African American luminaries living in Brookland—many connected with Howard University—grew to an impressive length, as described in chapter four. A college president, eminent deans, heads of departments, and professionals working in academia and government made Brookland something of a "Black Cambridge." From the 1930s onward, Brookland's African American elite employed Howard University–trained architects to build their residences. When Ralph Bunche was looking to build a home in Washington, he chose Brookland in 1941.

In the 1950s, Turkey Thicket became a magnet for athletes who went on to be high school and college basketball stars and, later, professional players. The basketball prowess displayed in the pick-up games on those courts became the standard for the best players in Washington for decades. Young players came to see if they could make the grade, and old-timers came to watch the action and reminisce. Today, a documentary about this legacy is in production.

Chapter five considers Brookland's strong roots in community activism. Black and white Brooklanders were civil rights activists. In the 1960s and 1970s, Brooklanders were in the forefront of the fights against segregation, equality in public education, and, later, to stop the Interstate 95 extension

through the neighborhood and city. They also fought to preserve the Brooks Mansion and designate it as a historic landmark and to bring home rule to the district. This tradition of activism lives on a questions about historic preservation, development around the Metro, and streetscape beautification are still debated energetically by Brookland residents.

A neighborhood comprised of fine examples of the architectural styles of the 19th and 20th centuries—with its commercial strip barely altered since the 1920s—is a rarity in the ever-changing Washington scene. A monastery with 40 acres of undeveloped land, just five Metro stops from the heart of the city, is a rarity indeed. Brookland is a treasure to be guarded—and celebrated in word and image.

(Brookland walking tours, history updates, and book events will be posted on www.BrooklandDChistory. com. All street references are presumed to be in Northeast if not identified otherwise.)

The Brooks Mansion provides the neighborhood with a direct connection to the earliest European settlers and enslaved Africans who arrived here in the 1600s. Col. Jehiel Brooks built this Greek Revival mansion, named Bellair, in 1835 after his return from Louisiana. He spent $25,000 on its construction—an exorbitant amount in his day. The grounds included an orchard, oak trees, a greenhouse, and gardens. Brooks was influenced by the landscape architect Jackson Downing. His heirs sold the land in 1887, and it was soon platted into residential blocks. Brookland is named for him. Brooks's descendants continued to live in Brookland until the 1990s. (HSKL.)

One

COLONIAL FARMS,
COUNTRY ESTATES, AND
CIVIL WAR FORTS

Brookland lies in what was called Washington County, outside the original boundaries of the city. Its rolling hills were once the hunting grounds of the Nachotank peoples, whose villages lined the Anacostia River, two miles to the south. The area included springs, ravines, and open woodlands of towering oaks, tulip poplars, catalpas, beeches, and other native trees. European settlement and colonial agriculture, with African slaves and indentured labor, began here before 1650. Under Charles I of England, land grants were distributed, and what became Brookland was part of Prince George's County. The names of family land holdings, such as Cuckold's Delight, Turkey Thicket, and the Inclosure, date from this era.

In 1835, Brooks Mansion, then called Bellair, was built as a plantation home for Col. Jehiel and Anne Queen Brooks. The Queen family was one of the old land-grant families, and with his marriage, Colonel Brooks gained control of 198 acres. A small portion of the large land holdings that remained in the Queen family became what was called South Brookland and is now part of Brookland proper.

Samuel Harrison Smith, who built a country farm estate called Sydney on what is now the Catholic University of America campus, was an intimate of James Madison and Thomas Jefferson, both of whom encouraged Smith to establish the *National Intelligencer,* the first daily chronicle of Congressional activity in the Federal City, in 1800. The letters of his wife, Margaret Bayard Smith, are collected in *The First Forty Years in Washington Society.* The W.W. Corcoran summer estate, named Harewood, was nearby and included a stone hunting lodge, still found on the road that bears its name. Salmon P. Chase's summer estate gave the Edgewood neighborhood its name. Other farms bordering the area include the George Washington Riggs Corn Rig and the Wood farm (both acquired to create the Military Asylum, later the Old Soldiers Home) and Nicholas Queen's property, now called Turkey Thicket.

With the death of Colonel Brooks in 1886 and the growth of the trolley lines, the land known as the Inclosure was marketed as Brookland. Early land speculators, such as Jesse Sherwood, teamed up with developers to create this new suburb.

Lawyer Jehiel Brooks arrived in Washington in 1828 with two goals: to gain a government appointment and to acquire property. By 1830, he had become the US Commissioner for the Cado and Quapaw Indians of Louisiana and had married into the land-rich Queen family, whose holdings stretched to Bladensburg, Maryland. Colonel Brooks spent much of his time after 1840 in a variety of legal actions. He defended his work with the Cado Indians in the Supreme Court and won his case. He defended his rights as a property owner against the US Army, encamped then at Fort Bunker Hill, during the Civil War. He fought the construction of the B&O Railroad line through his property during the 1870s and defended his record as an inspector of roads in Washington County. He also wrote many letters to the editors of the city's newspapers. (LOC, Mathew Brady.)

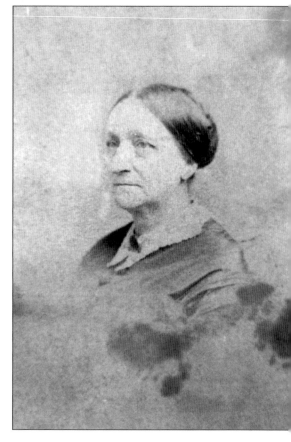

Ann Queen was a member of the tight-knit Queen-Wightt clan that had lived in rural Washington County since land grant days and owned over 600 acres of land. The mostly Catholic group had farmed and traded in this section for more than 200 years. Her children included Emilie, Nicholas Boyd, John Henry, Laura, and Frank. Four other children died in infancy. Her parents lived down the hill at what became Twelfth Street and Michigan Avenue in a far less ostentatious home, which was named Turkey Thicket (see page 19). Her descendants would live in Brookland for yet another 100 years. (GWA-GM.)

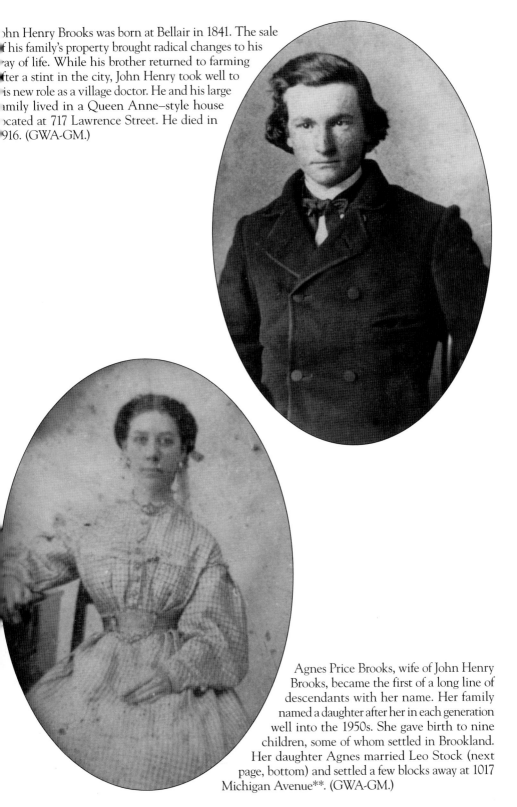

John Henry Brooks was born at Bellair in 1841. The sale of his family's property brought radical changes to his way of life. While his brother returned to farming after a stint in the city, John Henry took well to his new role as a village doctor. He and his large family lived in a Queen Anne–style house located at 717 Lawrence Street. He died in 1916. (GWA-GM.)

Agnes Price Brooks, wife of John Henry Brooks, became the first of a long line of descendants with her name. Her family named a daughter after her in each generation well into the 1950s. She gave birth to nine children, some of whom settled in Brookland. Her daughter Agnes married Leo Stock (next page, bottom) and settled a few blocks away at 1017 Michigan Avenue**. (GWA-GM.)

Jingle Wilson, Agnes Price Brooks and John Henry Brooks' son-in-law, wears a Rebel uniform. Confederate sympathies were common in Washington County. Most landowners had owned African slaves until 1862, as did the Brook family. The District's Emancipation Slave Commission paid compensation to former owners for 2,98? slaves. Records from these hearings describe the management and business skills of the newly freed African American workforce. (GWA-GM.)

Leo Stock, husband of Agnes Brooks (the daughter of Agnes Price Brooks; prior page), received his doctorate from the Catholic University of America and became a member of the history faculty from 1919 to 1941, while also working at the Carnegie Institute of Washington. The site of their home, 1017 Michigan Avenue, is currently the Vicariate of the Military Archdiocese of the United States. For generations, the Stock, Brooks, and Kelly families gathered there, at the "big house." (GWA-GM.)

12

The Rock Creek Parish at St. Paul's Episcopal Church (SPEC) was founded in 1712. Eighty-two acres of its original 100-acre glebe still surround the church and contain one of the loveliest cemeteries in the city. St. Paul's is the only congregation in the city that has an uninterrupted history of worship that can be traced back to colonial times. Members buried there who were early area land holders include the Wightt and Queen families, as well as George Washington Riggs of Riggs Bank. The congregation will celebrate its 300th anniversary in 2012. The original church was built in 1719 and demolished in 1775 to make way for the church pictured at right. This church was renovated and remodeled in 1868. Below, the church interior is shown, decorated for Christmas in the 1870s. Rock Creek Church Road once traversed the cemetery grounds and an old tavern building still stands within its grounds. (SPEC, Donald Harrell.)

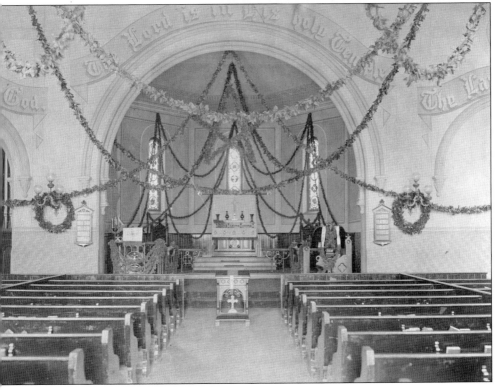

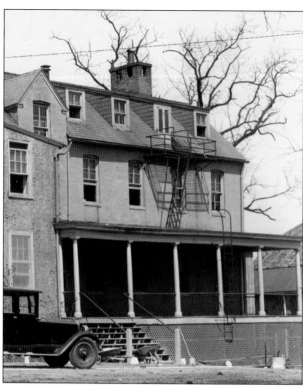

In 1804, Samuel Harrison Smith, the founding editor of the *National Intelligencer* newspaper, purchased 190 acres from the Duley family. That year, his wife, Margaret Bayard Smith, wrote, "We visited our retreat [Sydney**] . . . a good house on the top of a high hill, with high hills all around, embowered in woods, through an opening of which the Potomack, its shores and Mason Island [now Roosevelt] are distinctly seen." This is a 20th-century view of Sydney, which was later bought by the Middleton family and then CUA, which added to the original structure. (CUAA.)

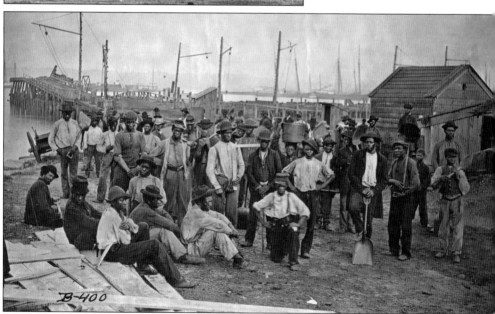

In August of 1814, anticipating the English invasion of Washington, the Smiths fled to Brookeville, Maryland, from their Sydney estate. After the Battle of Bladensburg, they returned and found a group of retreating volunteers at Sydney. Bladensburg was an important commercial port connected to Brookland by Bunkerhill Road, the route taken by the retreating American militiamen. Here African American laborers await work at the port of Bladensburg, Maryland. (NARA; photographer Mathew Brady.)

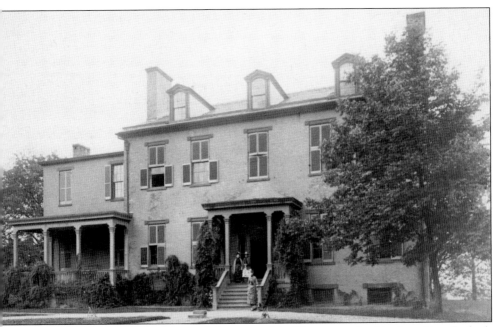

almon Chase, US senator from Ohio and Secretary of the Treasury under Abraham Lincoln, built his country house called Edgewood** in 1864. Chase was a lawyer and abolitionist who later became hief justice of the Supreme Court. His brilliant and beautiful daughter Kate rivaled Mary Todd Lincoln as a social arbiter and hostess during the Civil War years. She actively promoted her father's andidacy for president and herself as hostess of the White House. The view below shows Edgewood during the Civil War. After her father's death in 1873, Kate moved into Edgewood with her three aughters. Her marriage to Sen. William Sprague ended in divorce nine years later. From then on, she lived here in seclusion and died in poverty in 1899. Later, the Daughters of Charity bought the house, nd it became St. Vincent's Orphanage**. (Above, DCPLW; below, NARA, Mathew Brady.)

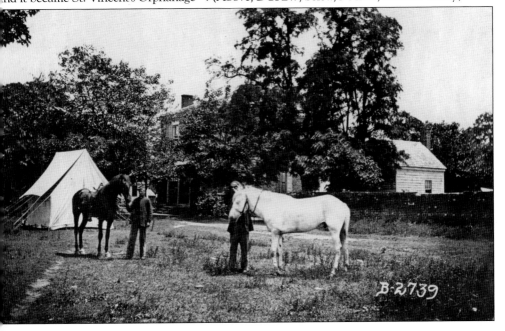

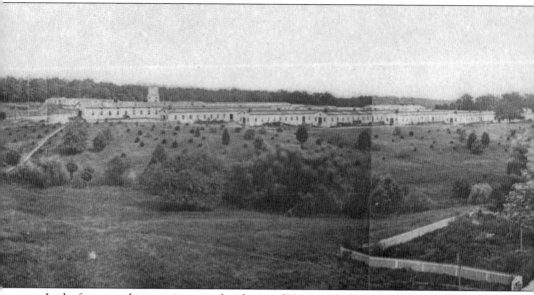

In the foreground, center, is an overhead view of Harewood, the country estate of W.W. Corcoran, man known as "the banker to the presidents." Corcoran was a southern sympathizer, and spent th Civil War years in Paris. His properties in the city and the county of Washington were confiscate by the government and not returned to him until 1869. In the background is Harewood Hospita

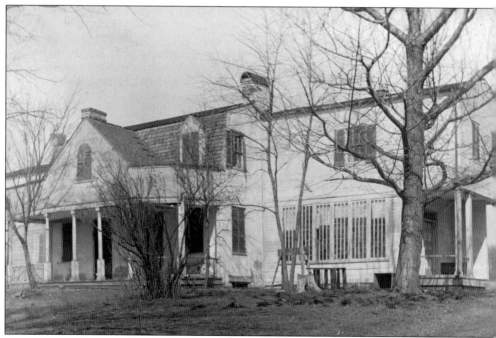

Shown is the front view of the Woods farmhouse** around 1900. This property was probably to th east of the Old Soldiers Home mess hall, on the north end of its grounds. It was constructed at th same time and in a similar fashion to Corn Rig (Anderson Cottage) with porches dominating th entranceways and gables lining the roof. Both features capitalize on the summer breezes available a the highest altitude in the vicinity. (LOC.)

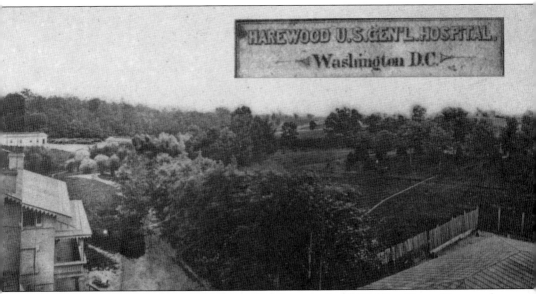

built in 1861, later the site of the Military Asylum, which became the Old Soldiers Home. Harewood Mansion stands on the summit of a hill, looking down toward the hospital buildings. This suggests that Harewood was near to where Archbishop Carroll High School is situated today, at the intersection of Harewood Road and Taylor Street. (DCPLW.)

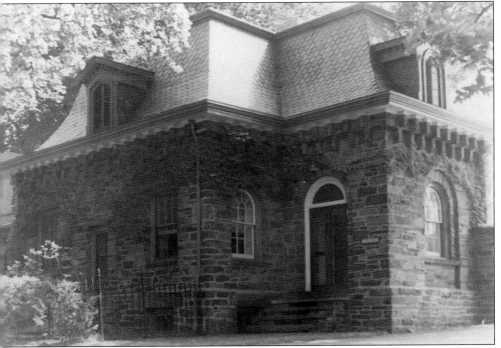

Corcoran's hunting lodge (now across from the National Shrine of the Immaculate Conception) and his estate were built in 1852 with his profits from the Mexican-American War and upon retiring from Riggs and Corcoran Banking. The lodge became a gatehouse for the Old Soldiers Home on the road named for the estate—Harewood. (Photographer Benita Bing.)

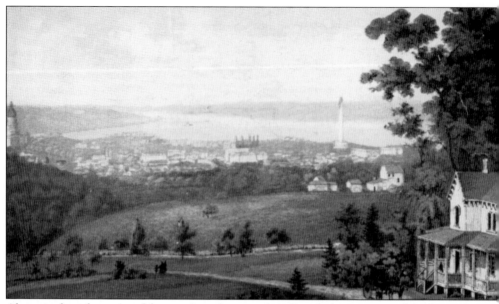

Above, in the right corner of the artist's rendering, is Corn Rig, the house renamed Anderson Cottage by President Lincoln in honor of his commander at Fort Sumter. From 1842 to 1851, Corn Rig was the country home of the George Washington Riggs family. Riggs was the business partner and neighbor of W.W. Corcoran, of the nearby Harewood estate. In the distance, the Capitol is on the left and the Washington Monument on the right. This third-highest elevation in the county offered cool breezes and fresh air during hot Washington summers, attracting many city dwellers to the vicinity in the 1840s and 1850s. From 1858 on, the Anderson Cottage (below) was the summer residence of Presidents Buchanan, Lincoln, Grant, Hayes, and Cleveland. Lincoln drafted the Emancipation Proclamation here in 1863. (DCPLW.)

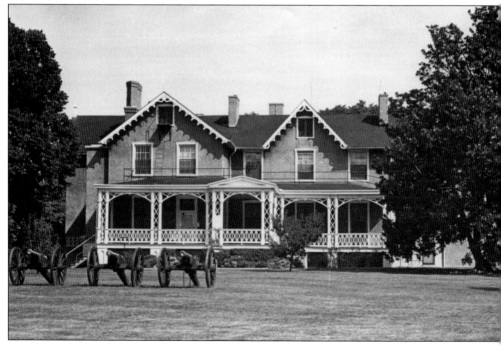

Nicholas Queen, father of Ann Queen Brooks and father-in-law of Jehiel Brooks, owned Queen's Hotel, a favorite with members of congress. In 1819, he inherited 236 acres in Washington County situated in the valley east of Sydney, Samuel Harrison Smith's estate. Queen's house was called Turkey Thicket** and stood near the intersection of Twelfth Street and Michigan Avenue. It was later bought by General Babcock and stood until 1966. (HSKL, Shannon.)

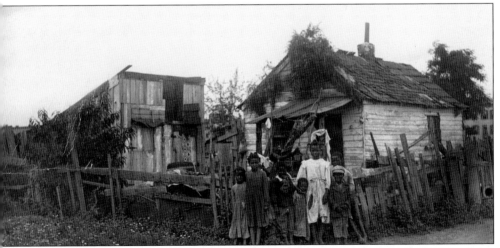

In 1860, free blacks represented 40 percent of Washington County's population, which included sharecroppers in what is now Brookland. Farms and country houses were the homes of enslaved African people as well as white landowners. Some owners, such as the Queens, encouraged their slaves to purchase their freedom by age 35. Freedman Basil Guttridge owned 10 acres near Turkey Thicket in 1860. Here is a typical dwelling of a black family in the area from that period. (LOC; photographer Mathew Brady.)

19

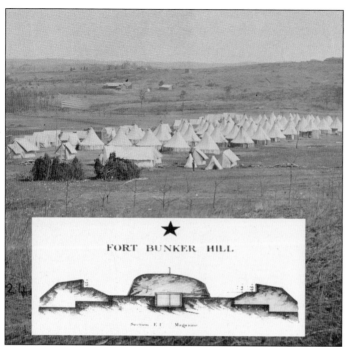

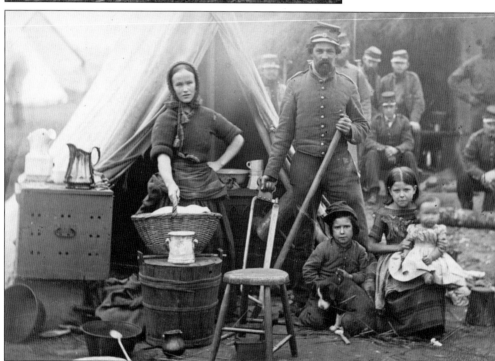

An encampment at Fort Slocum, one of 68 forts maintained for the protection of Washington during the Civil War, was located north of Bellair, the Brooks home, and situated in Queensborough (present day Turkey Thicket, see the map on page 22). The inset is the engineer's drawing of Fort Bunker Hill (elevation 226 feet) of which no photographs exist. It is a national park today and is still an excellent vantage point for viewing the neighborhood. (LOC, photographer Mathew Brady.)

During the Civil War, forts surrounding the Brooks and Queen properties (Slocum, Totten, Slemmer and Bunker Hill) were hubs of activity. Escaped slaves came looking for work and protection. Women like the one shown here at Fort Slocum, accompanied their husbands or came seeking work alone. The fort areas were clear-cut at the time of the Civil War to ensure the best visibility for the big gun placements. (LOC; photographer Mathew Brady.)

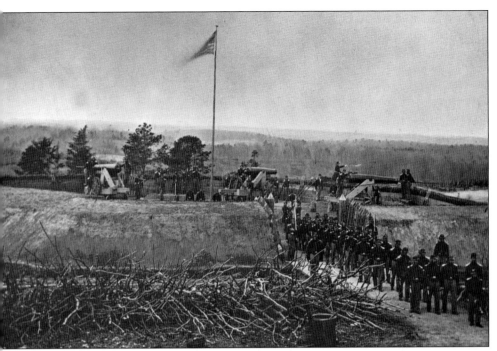

ort Slemmer, which stood at the top of the 233-foot hill where Harewood Road and Taylor Street now
ntersect, saw no action. That honor was reserved for Fort Stevens (above). Little of Fort Slemmer's
lay embankments survive today. (NARA; photographer Mathew Brady.)

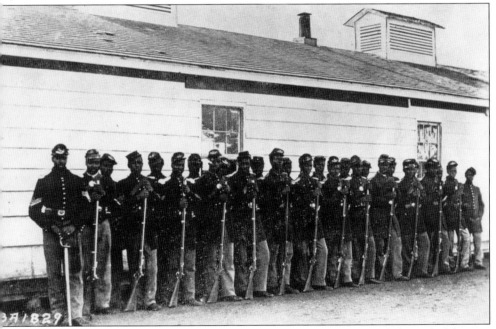

A group of African American troops are in formation at Fort Lincoln toward the end of the war.
ort Road—a stretch of which still exists near Sixteenth and Irving Streets, bordering Church of
Our Savior—was once a conduit for troops and supplies, connecting Fort Lincoln to other nearby
orts. (NARA; photographer Mathew Brady.)

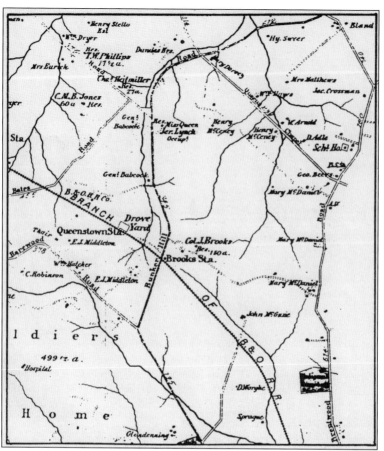

This map depicts the landholdings around Colonel Brooks's property in 1879. Kate Chase Sprague, of Edgewood, and E.J. Middleton, the purchaser of Samuel Harrison Smith's Sydney, are listed. Middleton's land would later be purchased for the creation of CUA. Queens Chapel Road and Brentwood Road still survive today, although much of what is labeled Bunker Hill Road on this map has become Michigan Avenue. (Hopkins, 1879.)

Just as old Catholic families shaped the development of Brookland, so did their Protestant neighbors. This is Jesse Sherwood in the 1880s when he began buying property in Brookland. He purchased 25 acres from the McCeney family to the east and south of what is the back of the Franciscan Monastery's land. He renovated the McCeney farmhouse before selling it to the Franciscans. He also lived at Eighteenth and Newton Streets and later built a home at 2420 Rhode Island Avenue**. (HSKL.)

Two

Institutional Beginnings and Foundations of Community

le of the Brooks estate in 1887 and the opening of a Brookland–Catholic University trolley line
d to the platting of 10 subdivisions by Benjamin F. Leighton and Richard E. Pairo. These developers
med Brookland streets without regard to the alphabetized city grid. Just after the turn of the century
l their original street names were changed: Fort Street became Otis, Providence became Newton,
d Lansing became Monroe. It was not until 1910, when homeownership financing was offered
y the Brookland Building Association, that a building boom changed the landscape dramatically.
killed craftsmen moved to Brookland and built their own homes, including early African American
ndowners Benjamin Henley and John Diggs, and Italian immigrant stonemason John Facchina. The
atholic University of America served as a magnet for numerous religious colleges and residences.
he development of farmland into the Franciscan Monastery and Trinity College and the founding
 St. Anthony's parish heralded an era of Catholic growth here. The Protestant Brookland Church
eague was founded in 1913 by A.A. Ormsby, and neighborhood sporting events were regularly
vered in the daily newspapers.

A commercial area formed around the train depots, including the first post office at University
tation. Industry developed along the rail line stops, and Brookland remained a transportation nexus
ith railroads, trolleys, and a major road connecting the city and country. Brooklanders aided in
e emergency response in 1906 when a tragic train wreck took place at Terra Cotta (just beyond
urkey Thicket). Institutional building began with the Brookland School and continued with the
re station and the Masonic hall. Roads were still dirt, and substantial sections were undeveloped,
t the village of Brookland was well established.

The legacy of the Progressive movement encouraged a relaxed attitude among some community
aders toward a growing black presence in Brookland. This thread of liberalism preceded an era
f increased enforcement of covenants and Jim Crow laws. Some black and white families, like the
miths and Jacksons, and particularly, their children, interacted freely during this period.

A small group of scientists who appreciated the bucolic character of Brookland settled here
uring this time. This included the first chief of ornithology for the National Museum (later the
mithsonian) Robert Ridgway, botany curator Theodore Holm, and botanist Carrie Harrison. Catholic
tellectuals were liberalizing influences during this period. These included ancient languages expert
lenri Hyvernat; Antoinette Margot, who emigrated from France to help Clara Barton found the
merican Red Cross; Thomas Edward Shields, the educational theorist who lived at 1326 Quincy
treet**; and Sr. Julia McGroarty, founder of Trinity College.

This barely recognizable scene is Brookland in 1890. Brookland Baptist Church**, just left of cent[..]
sits at the corner of Twelfth Street and Providence Street (today's Newton Street). In the middle of t[..]
west side of the block (left) is the Chissori home**. The east side of the street is an open field with[..]
sign advertising lots for sale. A group of children stands on the corner of Twelfth Street and Lansi[..]

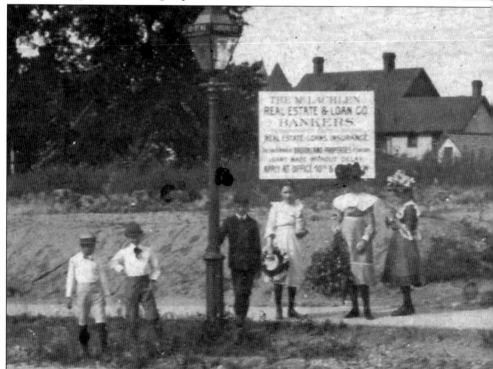

The large sign behind the children (from the picture above) reads, in part, "The MacLachlen Re[..]
Estate and Loan Company Bankers—Real Estate, Loans, Insurance—Brookland Properties—Loan[..]
made without delay— Apply at office—10th and (illegible)." Note the property behind the childre[..]
has a higher grade than the street. As Twelfth Street became a commercial center, this 3500 bloc[..]
was made level with the road to accommodate shops. The higher grade seen in the picture woul[..]
have been more appropriate for fashionable home lots in 1890.

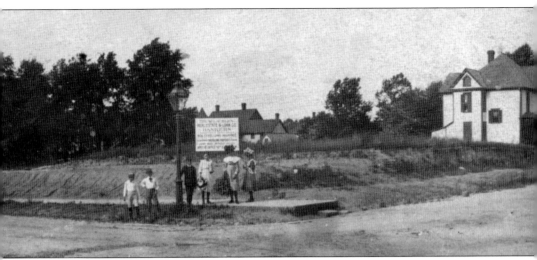

reet (now Monroe Street). In the 1890s, there were 76 African Americans living in Brookland; 1910, there were more than 100. Blacks connected to the old land-holding families of the county entually acquired their own land and sold to other African American families. Note the wooden dewalk and flattened dirt road. (DCPLW.)

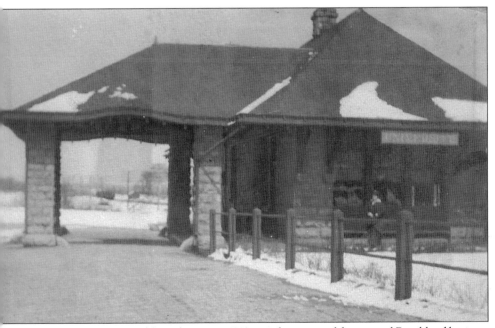

he University depot**, viewed from the east in 1910, was the center of the original Brookland business rea and remained standing until its demolition in the 1970s to make way for Metro construction. uring World War II, Franklin D. Roosevelt frequently disembarked the train from New York here nd was picked up by his chauffeur instead of facing crowds or the press downtown. (DCPLW.)

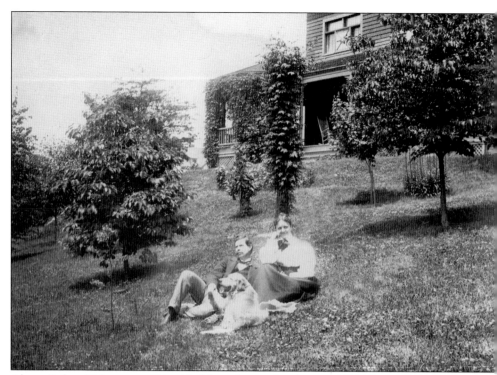

Above, Robert Ridgeway and his wife, Julia, relax on their lawn in 1890. They are at 3413 Thirteenth Street, the location of Rose Cottage, a turreted Queen Anne house that is still standing, though much altered. The photograph below shows Rose Cottage in 1893, looking toward the northeast from the middle of a vacant lot on Lawrence Street. Robert was a nationally recognized ornithologist whose many works include *Color Standards and Color Nomenclature* and *The Birds of North and Middle America*. Brookland's open spaces and woods, as well as its location on a north-south flyway for migratory birds, makes it an excellent spot for backyard bird-lovers to this day. (HSKL.)

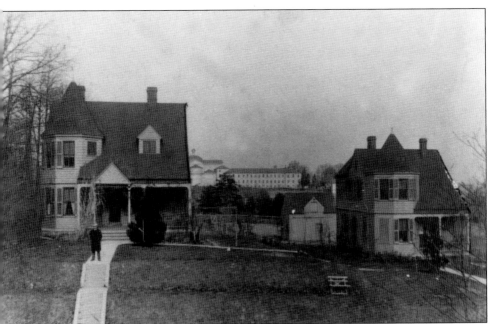

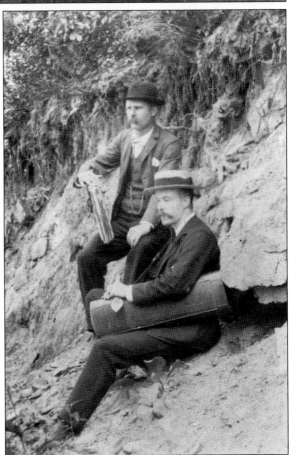

Theodore Holm was a Danish botanist who achieved fame through his fieldwork while trapped on the ice-locked ship Dymphna in the Arctic in the 1870s. He arrived in America and Brookland in 1888 and became a curator at the National Museum (later the Smithsonian). Among the friends he made in America was Joseph Krause, with whom he enjoyed hiking and rock climbing. When Holm built a house at 1438 Newton Street, Krause built one to the right, as shown, at 1440. The Franciscan Monastery is seen above, between the two homes. Krause helped Holm manage his garden, which he partly used for his botanical collection. While Holm remained a bachelor for life (see him also on page 61), Krause married and raised a family at their home (above, right). Krause is seated above Holm at right on an excursion. (GWA-GM.)

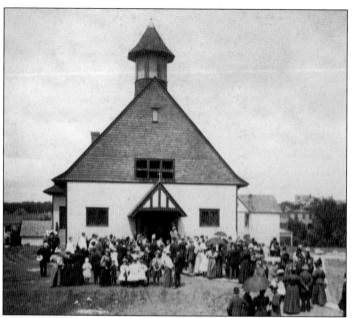

St. Anthony's church was one of the first institutions founded in Brookland. After several years of fundraising, the congregation built a wooden church at Twelfth and Monroe Streets, which stood from June 16 (St. Anthony's Feast), 1896, until 1938. Antoinette Margot, an associate of Clara Barton and Fr. Henri Hyvernat, a Semitics scholar and member of CUA's original faculty, founded this active parish, still flourishing today. (SAA.)

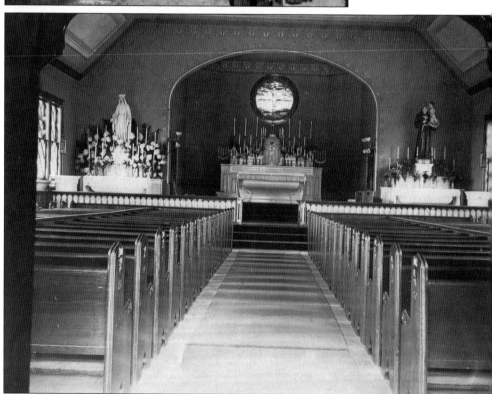

The interior of St. Anthony's church is shown in 1914. A great commotion startled the congregation during Sunday mass in 1927. When all rushed out after the final blessing, six-year-old Francis Smith was among those watching the steeple of Brookland Baptist Church (one block down on Twelfth Street) collapse in flames. The destruction of this neighborhood landmark remained fresh in his memory 70 years later, when he described it to one of the authors. (SAA.)

Antoinette Margot was born in Lyons, France, and joined the International Red Cross as a nurse in 1870. There, she met Clara Barton who invited her to help form the American Red Cross. Margot arrived in Washington in 1885, but a falling-out ended their collaboration. When Margot met Leonide DeLarue, the two new friends decided to move to Brookland and soon agreed that a Catholic church was needed there. (LOC.)

The friends sought out Fr. Henri Hyvernat, also a native of Lyons. Father Hyvernat worked with Antoinette Margot to receive permission from Cardinal Gibbons to set up a chapel in her home. He served the newly formed mission parish of St. Anthony's church. He is shown here in a formal portrait of the founding faculty of CUA. (CUA.)

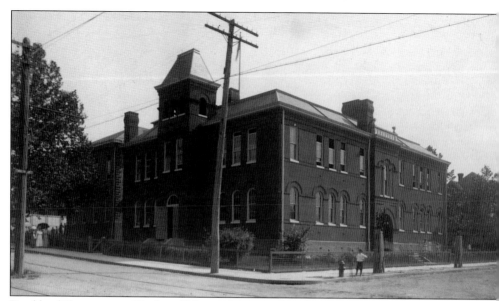

Brookland Elementary, at Tenth and Monroe Streets, replaced Bunker Hill as the local school for white in 1891. Additions built in 1896 and 1903 failed to remedy overcrowding, and several prefabricate classrooms were installed in the 1920s. Brookland Elementary moved to a building on Michiga Avenue in 1970. The old school was used for the handicapped, then by Luke C. Moore Academ an adult education program that still serves young adults today. (SSMA, Hayden Wetzel.)

The Brooks estate was sold and its remaining 134 acres were platted and named Brookland in 188. Ida U. Marshal purchased and sold the Brooks Mansion to the Marist Fathers who built the additio in 1894. They sold it to the Benedictine Sisters who started St. Benedict's Academy, an elementar school, in 1905. In 1927, the Benedictines were invited to teach at St. Anthony's Grade School, an the mansion became their convent. Pictured is the second-grade class in 1906, posing in front of th Brooks Mansion. (SAA.)

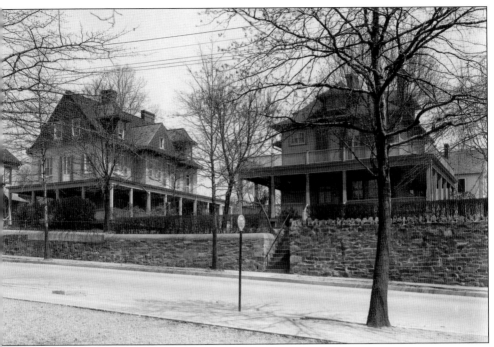

In this picture, where the post office now stands, Fr. Henri Hyvernat's home (right), located at 3405 Twelfth Street**, sits next to Antoinette Margot's at 3415 Twelfth Street (left)**. While Father Hyvernat traveled extensively, particularly to the Middle East, Margot remained close to home. Like many converts, she was a zealous Catholic. She acted as sacristan and trained altar servers for more than 30 years. These friends lived next to each other and across the street from St. Anthony's church until her death in 1925. (CUAA.)

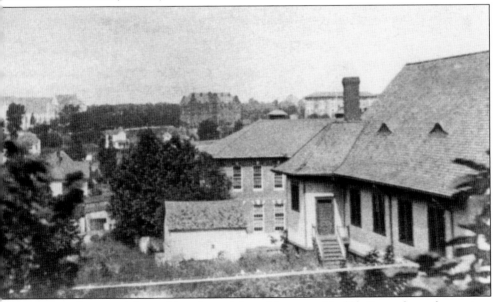

This view from the second floor of Antoinette Margot's house on Twelfth Street shows the spacious backyards, woodsheds, and fields between the village center and the Catholic University of America in 1910. (CUAA.)

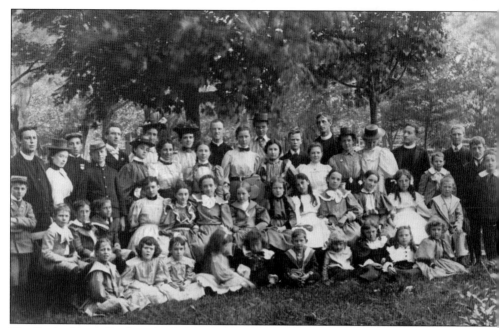

The St. Anthony's Sunday school class is on a summer outing to Marshal Hall Amusement Park in Maryland. In the group are three Paulist fathers, and two granddaughters of the Brooks family. Helen Brooks appears standing in the third row, eighth person from the left, and Emily L. Brooks is seated directly in front of her sister. (SAA.)

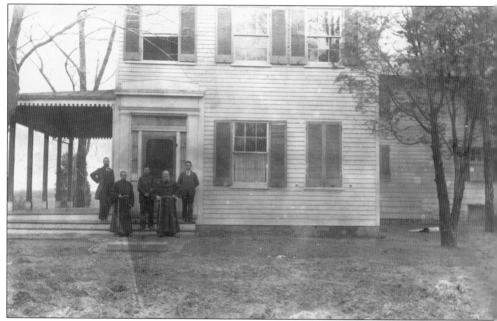

The first members of the Franciscan Monastery community stand beside their new property at 3530 Eighteenth Street, the McCeney farmhouse, in 1898. Fr. Godfrey Schilling, the leader of the community, is standing right of center with his hands on his hips. In short order, these determined monks turned a farm into a nationally known pilgrimage site. Br. Felix Burkhart wrote, "The place where the monastery is located was a wilderness when we first came." (SAA.)

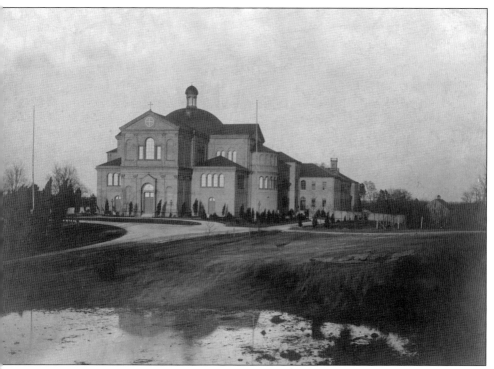

The Rosary Portico, which now encloses the Monastery entrance garden, had not yet been built in 1899. The roof of a barn is seen on the far right. In front, there are two flagpoles—one for the US flag and the other for the Vatican flag. (CUAA.)

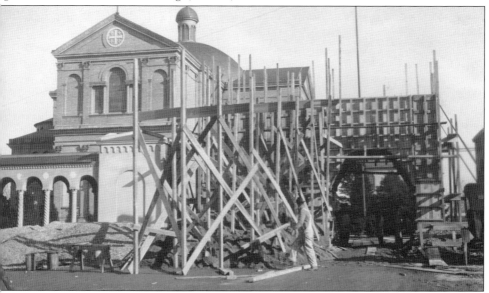

Architect Aristide Leonori, a tertiary Franciscan, designed the Shrine of the Holy Sepulchre, the monastery's main church. The church and its grounds house recreations of shrines from the Holy Land and Rome, including the Bethlehem Grotto, the Annunciation Grotto, and the catacombs of Saints Sebastian and Cecelia. Leonori's ecclesiastical designs are found throughout the world. Pictured is the portico under construction in 1915. (FMA.)

This view shows the east side of the Franciscan Monastery, which is seen on the summit of the hill in the background. Rose Lord, whose family owned property in the area, married James Sherwood, who, with his brother Jesse, developed additions to Brookland, managed a bank, and built the Newton Theater. This is what would have been seen from the vicinity of modern-day South Dakota and Michigan Avenues in 1890. (FMA.)

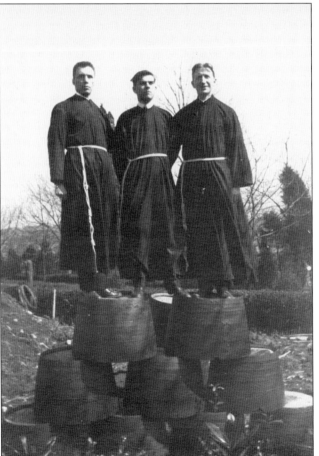

Three friars stand on barrels, possibly containing beer. The first friars at the monastery were from a variety of European backgrounds, but German roots predominated. The founding group included their leader, Fr. Godfrey Schilling, and Brothers Steinhauser, Kestering Burkart, and Walter. (FMA.)

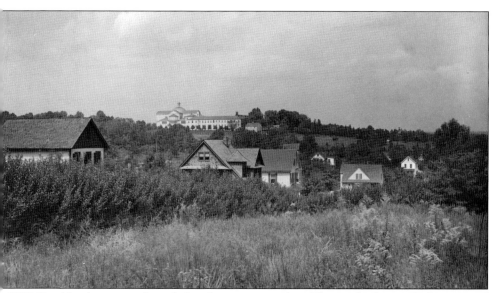

n 1900, Brookland was sparsely settled, with many vacant lots. This northerly view, looking toward ne Franciscan Monastery, shows the location of archaeologist Jacob Wiltberger's 1892 dig of Paleolithic pearheads and stone implements. There were many staff from the National Museum living in rookland (Leonhard Stejneger, Robert Ridgeway, Theodore Holm, and Carrie Harrison) at this me. Their common interest in scientific pursuits may have encouraged archeological investigations ke Wiltberger's. His artifact cache is still in the Smithsonian collection. (FMA.)

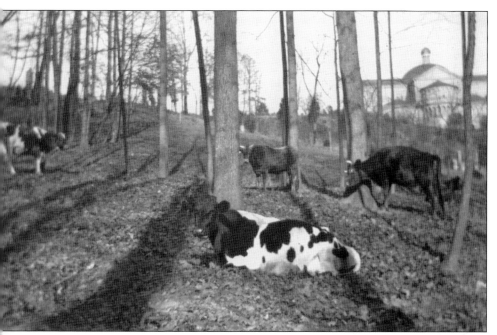

he Order of Friars Minor followed a rule of self-sufficiency. In 1900, this required food production nd keeping livestock, like the dairy cows pictured here, as well as geese. Dairies were part of emerging rookland, including those at the Old Soldiers Home, the nearby commercial operation of Firman Horner, and some homeowners who kept cows as well. (FMA.)

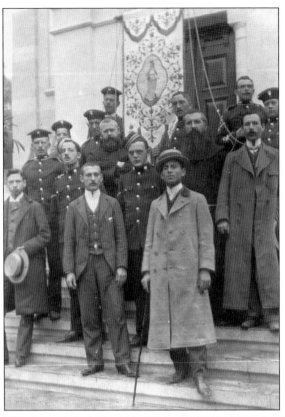

As the 20th century proceeded, Italian construction workers, artisans, and shopkeepers—like the Chissori and Facchina families—became a sizable percentage of the community here and were served for 50 years by several Italian stores, including Mancuso's deli (where Viareggio's was later on Twelfth Street, between Otis and Perry Streets), and Migliaci's at the corner of Monroe and Twelfth Streets. Several of the homes of Italian craftsmen still display artful stone details. Members of an Italian religious fraternity (left) are on pilgrimage at the Franciscan Monastery. Below, workmen perform the arduous labor of earth removal from the future grotto site in the monastery gardens, c. 1910. Signore Leonori's fame as an architect in Italy may well have attracted Italian workers to the area. Once the big grotto area was carved out, wooden frames and poured concrete were used to create a man-made cliff and niche, where the statue of the Virgin Mary was placed in a replica of the central shrine of Lourdes. (FMA.)

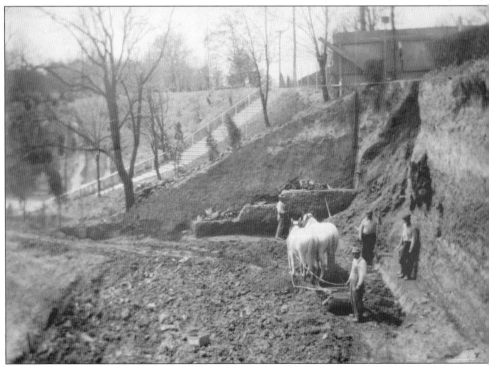

In 1900, Lincoln Road was sometimes flooded by a tributary of Tiber Creek. North Capitol Street stopped at Michigan and continued as a dirt road leading to Middleton**, the former home of Samuel Harrison Smith, then owned by CUA. Trinity College owned land abutting the Old Soldiers Home on the north and Glenwood Cemetery on the south. In 1957, North Capitol was extended and became a major thoroughfare between Maryland and downtown. (TUA.)

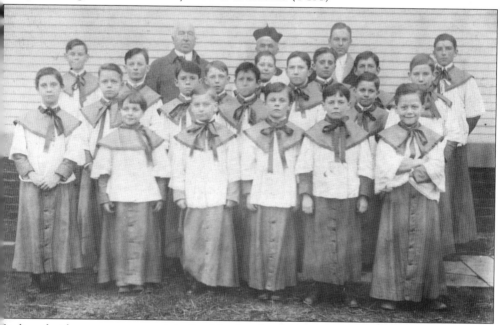

Finding choirboys was an easy task in Brookland in the 1890s when families were large. Pictured are pastor Fr. Thomas David Williams (center, back) and organist Mr. Wells (left, back). (SAA.)

Fr. Thomas David Williams (center), pastor at St. Anthony's church from 1910 to 1918, later became Antoinette Margot's biographer. Mr. Wells, the organist, is pictured at left. Parish organizations were in full swing at this point. The Sodality of Mary, for women, was founded in 1905, and the Holy Name Society, for men, was founded in 1908. (SAA.)

When Trinity College opened in 1900, an open barouche was considered the fashionable means of transportation, especially for a special outing for seniors. One of the drivers in top hats may very well be John Diggs. His was one of the first African American families to live here after the development of the Brooks estate. Diggs moved with his wife from urban central Washington to the country—Brookland. During his decades at Trinity, he bought much of the 1300 block of Otis Street.

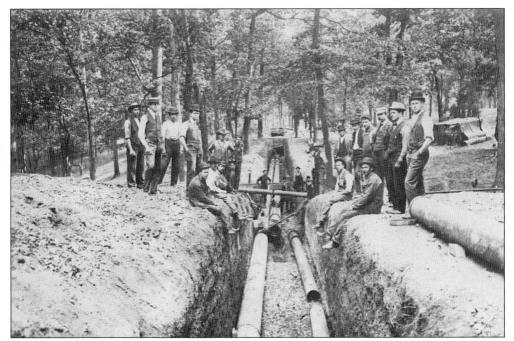

This 1910 photograph shows workmen at the Old Soldiers Home laying pipe as part of the extensive building projects that changed the landscape, obliterating some of the farm buildings that dated back to before the Civil War. (NARA.)

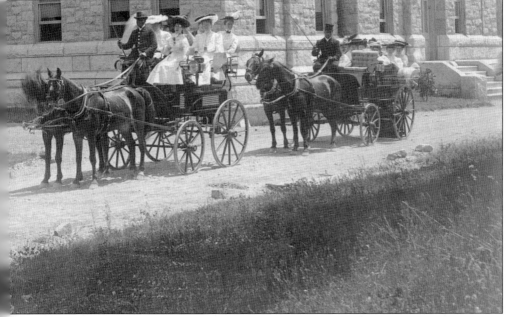

including one lot that had a pre–Civil War structure to which he built an addition. When he retired as a building engineer from Trinity College, he needed to sell several lots to fund his retirement. He was fond of reminding the Trinity Sisters of Notre Dame about this, which he frequently did, as he lived next door to them. (TUA.)

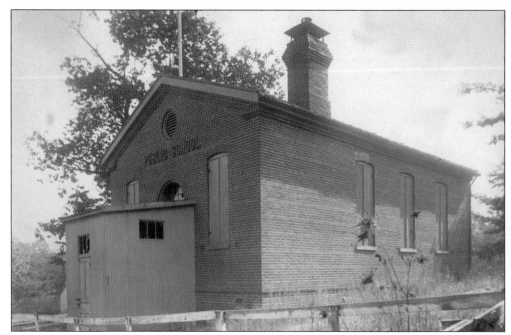

Mary Church Terrell was influential in founding Bunker Hill as a school for African American children in Brookland. From 1900, Bunker Hill School** operated under the colored division and was popularly called the Brookland Colored School, before reverting to the White Division in 1926, after which there was no school for African American children in Brookland until 1945. The school was named for Bunker Hill Road, which ran between the school and the nearby Civil War fort. (SSMA-HW.)

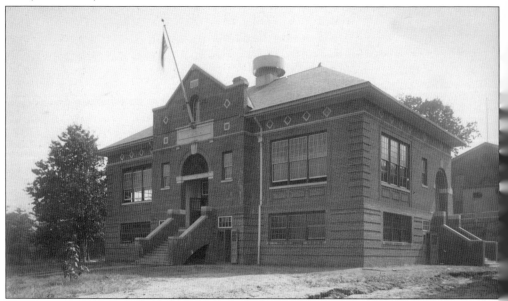

The current Bunker Hill Elementary was built in 1940 for white students and is the third building on this site to carry that name. A one-room brick schoolhouse originally opened here in 1883, and a two-room building directly in front of the earlier one opened in 1911. The present structure was expanded four times between, 1944 and 1965, as the neighborhood grew. (SSMA-HW.)

Mary (left) and Agnes Stock, great-granddaughters of Colonel Brooks and daughters of Leo and Agnes Stock, are standing in their yard, at 1017 Michigan Avenue**, in 1915. Mary married into the Kelly family and Agnes into the Cahills. Mary spent her married life on Otis Street, near the Franciscan Monastery. Their Michigan Avenue home, which backed onto Twelfth Street was called "the big house" by the extended family. (Molly Murray.)

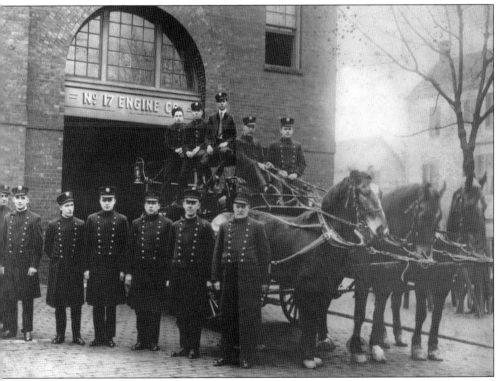

The Engine Company No. 17 building was constructed in 1902 and remains a working fire station on the south side of the 1200 block of Monroe. There was a hayloft on the second floor, and the loft door and winch used for hauling bales of hay are still in place. A basketball court in the back was used by area children in the 1960s. The firehouse was designated a historic landmark in 2004. (Courtesy DC Engine Company 17.)

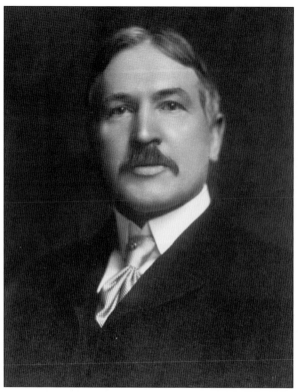

Prof. Charles McCarthy taught at CUA from 1904 to 1939, serving as a full professor of history and as dean of students. He was a prolific author of books, scholarly articles, and book reviews. He was awarded the Benemerenti Medal by the pope for service to church and family in 1940. McCarthy married Evelyn McKenna in 1887, and they raised a family in their large house at 3425 Twelfth Street** (below). According to a letter written by Jehiel Brooks in the 1880s, the high, empty lot to the left of the McCarthy house was the site of the Nicholas Queen family burial site, which is now the Rosary House at Twelfth and Monroe Streets. To the right are the homes of Antionette Margot and Henri Hyvernat, pictured on the next page and page 31. (CUAA.)

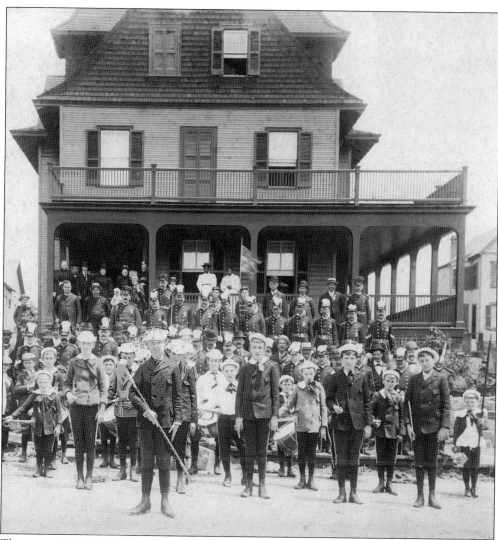

This interesting gathering appears to be welcoming Antoinette Margot and Leonide DeLarue to their new house** at 3405 Twelfth Street. Children dominate the group but in the background, the Knights of Columbus are in third-degree regalia, including one African American. Two African American women are also seen on the front porch. Before the 1920s and the enactment of Jim Crow laws, some whites in Brookland demonstrated relaxed racial attitudes. This is the same house as shown on page 31 (top, left). (SAA.)

By 1915, the Franciscan Monastery was much as it is today. The main church, with its catacombs, and the grotto were completed. Its gardens were still being laid out. Busses carrying pilgrims are shown arriving by way of Perry Street. The edge of what would become Fort Bunker Hill Park is seen at the left. (FMA.)

The upper parking lot for the monastery has always been at the intersection of Fourteenth and Quincy Streets. The monastery portico, which surrounds the entranceway today, was not added until 1915. It was designed by Washington architect John Joseph Early, who also designed Meridian Hill Park (Malcolm X Park) and some of the concrete statuary at the monastery. (FMA.)

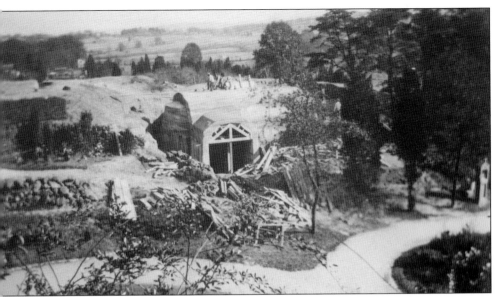

Construction of the tomb of the Blessed Virgin in the east wall of the sunken garden is ongoing in this photograph. This area was completed in 1913, including the Lourdes grotto, replicas of ancient tombs, and the Way of the Cross. On the far right-hand side, a brick structure shaped like a police call box is the first of the Stations of the Cross, much as it looks today. (FMA.)

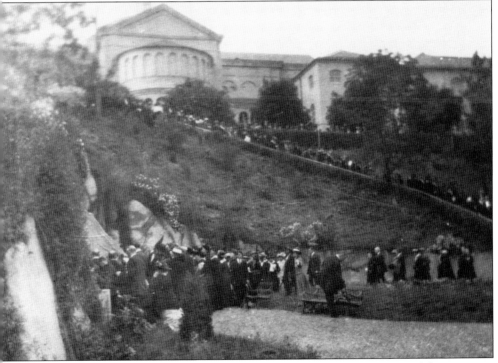

In 1915, a group of pilgrims processes into the Lourdes grotto, the centerpiece of the extensive monastery gardens that remain open to the public. Worshippers still gather here on Good Friday for the Stations of the Cross and on Easter Sunday for the sunrise service. The fields to the east and Fort Bunker Hill to the west ensure a quiet retreat to this day. (FMA.)

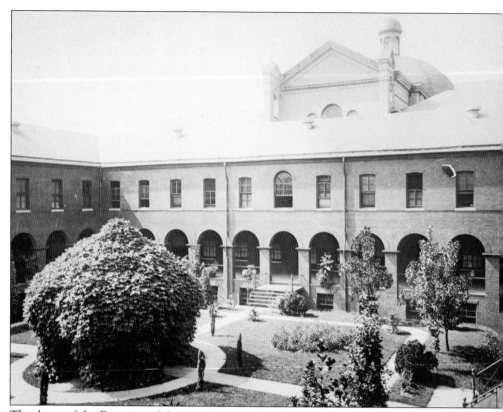

The dome of the Franciscan Monastery's main church, Mount St. Sepulchre, appears at the top right. In the foreground is the private garden in 1915, a place for prayer and meditation reserved for the private monks. Below is a view of the friars at leisure in their cloister. (LOC.)

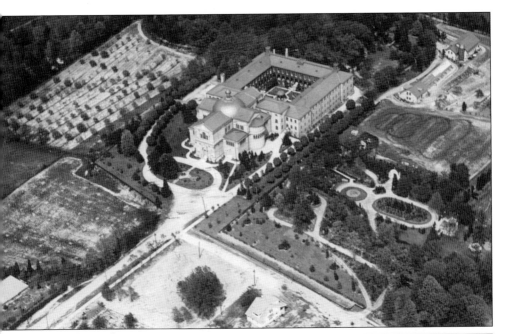

This 1920 aerial view shows the Monastery church, the landscaped grotto to the right, a terraced orchard to the left, and the parking lot in the bottom center. In the upper right-hand corner is the monastery barn. (FMA.)

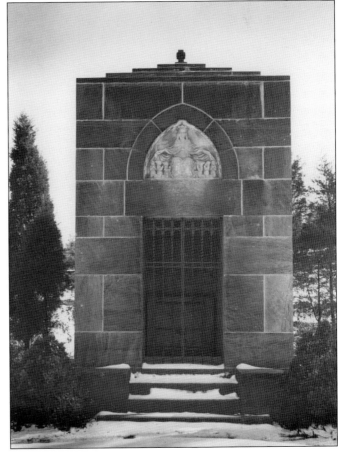

Fr. Thomas Shields founded the School of Education at CUA in 1902. He also founded the Sisters College, which trained many teachers for the nation's parochial schools. His progressive ideas about elementary education are documented by Justine Ward, his biographer. He was buried in 1921 in this Sisters College mausoleum, located at the end of Varnum Street, where several orders of religious women still have houses. (CUAA.)

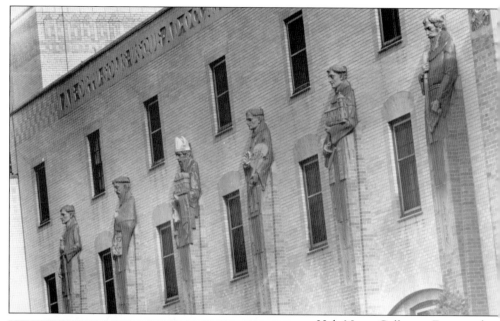

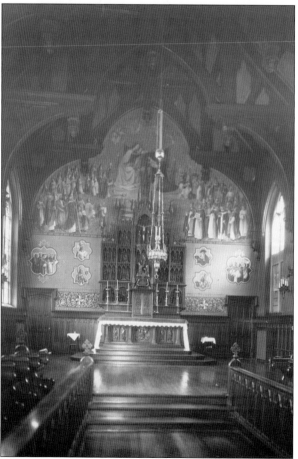

Holy Name College at Fourteenth and Shepherd Streets was built in 1910 as part of the Franciscan seminary and has a similar central courtyard. The Franciscans sold the building to Howard University and it became a divinity school in 1987. A small museum inside (open by appointment) holds an extensive collection of ancient Ethiopian Iconic art and manuscripts. This detail of Holy Name College shows Franciscan luminaries in high relief on the exterior. (DCPLW.)

Dominican House of Studies, across from CUA on Michigan Avenue, is the training institution for the Order of Preachers. It has always offered its own independent curriculum and granted degrees. For many years, Sunday services attracted members of the community to this elegant chapel with dark wood paneling and paintings of saints of the order, including events from the life of Saint Dominic, the founder. It remains intact and open to the public for worship. (CUAA.)

Cuvilly Hall** had been an old tavern and inn owned by the Rose family. In 1913, Trinity College purchased the inn on Lincoln Road, which at that time, ran through campus. This building served as an infirmary during the influenza outbreak and later housed the art and music departments until it was torn down in 1957 to be replaced by a dorm. (TUA.)

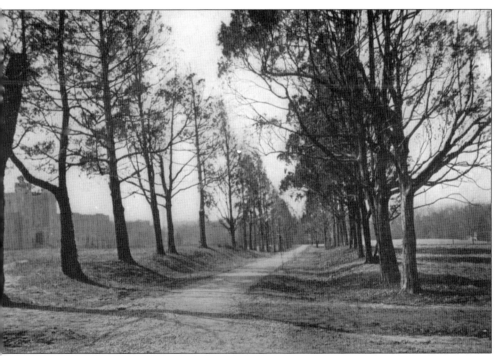

Holy Cross College**, seen on the left, was located on the north end of CUA's campus in this bucolic view. The Holy Cross Fathers lived and studied there. This magnificent edifice was replaced with what is now O'Boyle Hall in the 1920s. Old Marist College was nearby, as well as Capuchin College, which remains on the site of Fort Slemmer. (CUAA.)

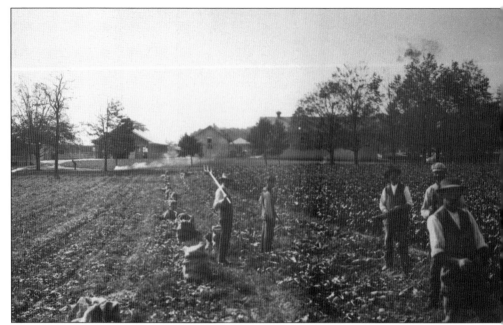

This farming scene would not have struck anyone as anachronistic in the first decades of the 20th century. Brookland was surrounded on every side by farm operations like those shown in this field at the Old Soldiers Home. Heading out of the district by Bunker Hill Road, there were still many truck farms. Well into the 1960s, these farms sold their wares in Brookland alleys. (NARA.)

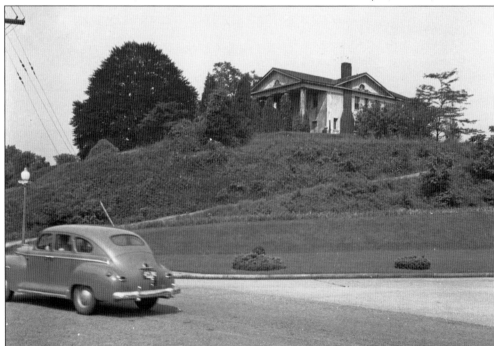

This rammed-earth house was located at 1300 Rhode Island Avenue**. It was reportedly built in 1773, with two-feet-thick walls of tamped earth packed between wooden forms. This house stood overlooking a busy commuter route for nearly 200 years. (HSKL, Wymer.)

Legend has it that as Joseph Krause's family grew, the friendship between Krause and Holm cooled. According to Helen, Krause's daughter, Holm could not stand all the noise from the children next door and moved to a farm in Clinton, Maryland. Krause purchased land from Holm and established a family enclave here where his daughter Helen Krause Caruso (of Caruso Florist) and her family lived into the late 20th century. (GWA-GM.)

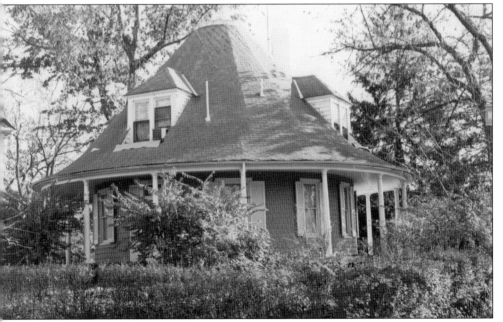

The "round house," located at 1001 Irving Street, was built for John C. Louthars in 1901. It was designed by architect Edward Nolze. Legend has it that Louthars's wife was confined to a wheelchair, and the open floor plan with interconnecting rooms was ideal for her improved mobility. The stairway in the center is circular. (GWA-GM.)

This view from the Franciscan Monastery entrance faces west to Quincy Street. The stately homes on the 1200 and 1300 blocks, with their large lots, were completed by 1930. A bishop, a music theorist, and several religious orders had houses on these blocks. The Franciscan Monastery had become the center of the residential neighborhood, when just 15 years before, it sat well away from the activity around University Station. (FMA.)

Three

FROM RURAL VILLAGE TO MAIN STREET

During the period 1910 to 1929, trolley service improved, with tracks coming up Monroe Street, turning onto Twelfth Street, and terminating at the Quincy Street turnaround. Commuting from Brookland was easy, and the neighborhood consequently grew. George Stantameyer, a builder who lived here, began filling in more of the empty lots in central Brookland, in partnership with James Sherwood, the president of the Hamilton National Bank, located at Twelfth and Newton Streets.

Three institutions—Brookland Baptist Church, the King David Masonic Lodge, and St. Anthony's church—grew with the neighborhood and formed the core of the Twelfth Street business district. Shops, financed by local entrepreneurs, began to pop up between Monroe and Newton Streets. With all the services wanted by a vibrant community, Brookland prospered. Busy Twelfth Street thrived with enough retailers to serve a community of 2,000 residents: Migliaccio's Italian Deli, Hong Lee laundry, Chilleni's tailor shops, Bonhert's bakery, Gertrude King Notions, Chisari's Shoe Repair, Leonard's Market, Neil Inc. Men's Furnishings, Sol Freedmen's dry goods, and the Penny Lee Shop for the stylish homemaker. A parade and ribbon-cutting inaugurated the paving and lighting of Twelfth Street in 1927.

During this era, the Hospital for Sick Children moved here for the healthful country surroundings, as did the Benedictine Monks who moved into their current location, 40 acres on South Dakota Avenue, where they established St. Anselm's Priory School.

With stable incomes and a housing boom, African Americans were able to buy land and homes in certain sections of Brookland. In spite of Jim Crow laws and prejudice, blacks—numbering 76 in 1896—doubled in number and owned land, farmed, and built homes and businesses.

The growth of the African American community here did not escape the attention of the Brookland Citizens Association (founded in 1899), which, while advocating strenuously for improvements in city services and infrastructure, was also adamant about containing the "Negro" population. One of the primary tools used in this effort were covenants that prohibited home sales to African Americans.

Nonetheless, because of long-established black landownership and homeownership here, there were areas free of covenants. African American laborers and professionals found stable work at area institutions and downtown with the federal government. Howard University faculty began to move into the neighborhood in numbers and created what would become an elite enclave of educated, professional African Americans.

This 1917 view from CUA Graduate Hall looks east up Monroe Street and Michigan Avenue a the left. The large building (top center) is Brookland Elementary. The Kuhn home is right behin it, located at Lawrence and Ninth Streets. Father Kuhn, who grew up there, started Anchor Ment Health, now located a block from his childhood home. The Monroe Street Bridge has not yet bee built, and the residents considered the railroad crossing dangerous. A trolley line running in bot directions, with its electrical wires and poles, occupies the center of the street. (CUAA.)

Trinity College students wait for the downtown 80 trolley on Michigan Avenue. To go to "B-land as students called it, they usually walked—even after the new trolley appeared in 1915. Beginnin in the 1930s, on Friday evenings, students went to the Newton Theater or the Hot Shops, locate at Fourteenth Street and Rhode Island Avenue. They arrived and departed from the Universit train depot. Trinity was very much a part of Brookland, and its orchestra played at communit events. (TUA.)

This 1916 yearbook illustration shows CUA students involved in an elaborate initiation rite. Evidently, to show that he is a solid member of his class, the acrobatic young man pictured holds onto a contact on the trolley overhead wire just long enough to be in danger of electrocution. For his trouble, he is prodded by a sophomore as the Brookland-bound car approaches. (CUAA.)

In 1921, McCarthy's Light Lunch** is at Twelfth Street and Michigan Avenue. Shops on this end of Twelfth Street included a tavern, dry cleaner, and barber. Kerry o Derry would become Ellis Island in time, and then San Antonio Bar and Grill. Pat's, a restaurant and bar, as was Chimes, were also on this end of Twelfth Street. In the 1930s, a Safeway would be built in the next block up. Today, a triangle garden built by the Brookland Garden Club is just north of this site. (CUAA.)

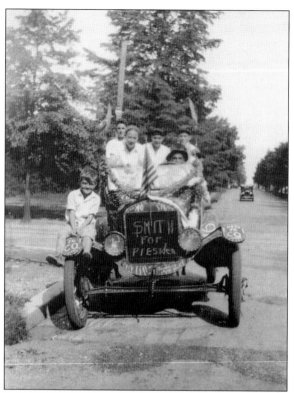

This group of boys may be promoting the governor of New York's bid for the presidency in 1928, but they are also enjoying a joke. They are mostly named Smith. On the front left bumper is Francis Smith. He spent most of his life in Brookland. His old relations were farmers on Michigan Avenue, but he and his family were town dwellers. (Rita Smith.)

In March 1924, the St. Anthony's Dramatic Club performed *My Irish Rose* at the Masonic hall. The cast, pictured here, included Florence Mattimore (later McGuire), seated far right, and Anna May Fitzmorris (later Moynihan) to her left. Thomas Brosnan, of Otis Street, and the younger Leo Stock, the great-grandson of Colonel Brooks (far right, second row), were also in the cast. Many community events were held in the Masonic hall. (SAA.)

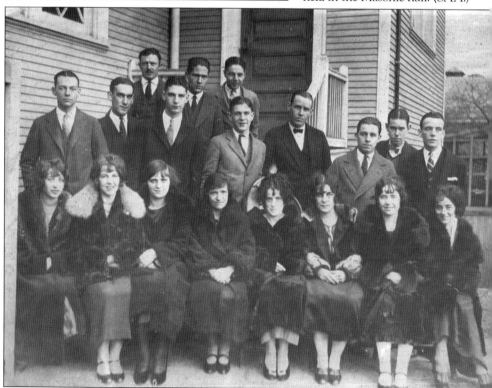

oses were of great terest to Brookland omeowners in the 1920s. he Rose Society met onthly to discuss the ltivation of roses and share information and ttings. James Sherwood nd his wife were nthusiastic supporters the Rose Society and id gardeners. The love roses spread from the omes to the institutions. he Franciscan Monastery as particularly notable r its rose plantings, and still is today. (CUAA.)

Rules, Regulations, and Premium List

FOR THE

Fifth Annual Rose Exhibition

UNDER THE AUSPICES OF

The Brookland Citizens' Association, The University Heights and Vicinity Citizens' Association

The Rhode Island Avenue Suburban Citizens' Association and The Rose Society of Brookland, D. C.

IN MASONIC TEMPLE

Corner 12th and Monroe Sts., Brookland, D. C.

MAY 25th and 26th, 1916

Doors open to the Public after 6 P. M., May 25, and all day and evening May 26

There is no charge for admission and the Public is cordially invited to attend. Children should be accompanied by some one responsible for their good behavior.

As the Rose Season in this climate varies as much as two weeks in different years, the Committee reserves the right to change the dates of the Exhibition upon one week's notice, should that be found necessary.

All Roses exhibited are the property of the exhibitors and should not be handled or taken at any time without permission of the owners

DATE CHANGED TO MAY 29th & 3(

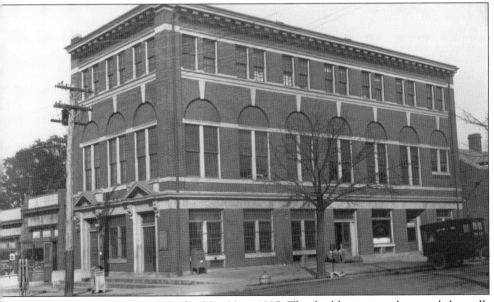

lere is the King David Masonic Lodge No. 28 in 1925. This building not only served the well-onnected Masonic community but also housed the Brookland Post Office on the ground floor. On 1e second floor was a hall with a stage, suitable for community gatherings, dances, and theatricals. 'his made the Masonic hall the social center for many Brooklanders. (HWKL.)

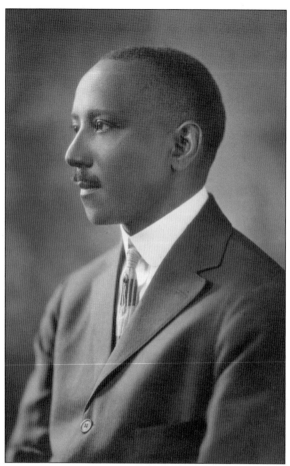

Thomas Wyatt Turner was a renowned botanist and an advocate for black Catholics. From 1914 to 1924, he was professor of botany at Howard University. In 1917, he applied to graduate school at CUA, where he had taken summer classes in 1902, but in 1917, he was told that "Negroes" were no longer admitted there. In 1925, Turner founded the Federated Colored Catholics, an advocacy group for black Catholics. Years later, Turner's daughter Lois lived in Brookland and was lifelong friends with her classmate and fellow Catholic, James Quander. (HWA.)

St. Anthony's original 1897 church** is shown from the north side. This 1925 image also shows the trolley tracks, which now turn north to go up Twelfth Street. Previously, most household items had to be delivered or carried from the train station shopping area. With the trolley on Twelfth Street, there would be more shops and easier access to downtown. (HSKL, Shannon.)

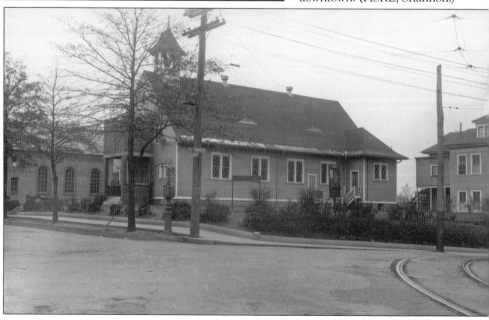

hese are two houses of study for religious men that were on the 700 block of Monroe Street: the alvatorean House** (above) and the Marist House of Studies** (below). Maloney Hall and the Mission Society Building** at CUA can be seen behind it. This now vanished section of residences cted as a bridge between the university and the neighborhood situated along the west side of the ilroad tracks, where now stands the Bennett Beauty Academy. Many religious houses remain in rookland, including the Benedictines, Josephites, Capuchins, Redemtorists, Lasallettes, Carmelites, Missionary Servants of Christ, Oblates of Mary Immaculate, Oblates of St. Francis de Sales, Paulist athers, and Piarist Fathers. (Both CUAA, Mankiewicz.)

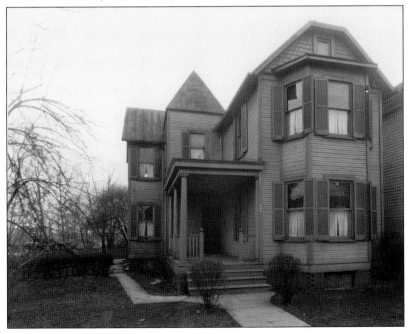

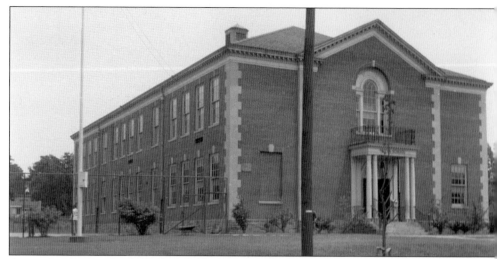

A new elementary school for white students (named for the DC newspaper publisher Crosby Noye was completed in 1931 but with only four rooms. Additions in 1940 and 1960 took the school to capacity of 728 students. When John P. Davis was unable to enroll his son there in 1944 because his race, he sued the school board, aided by fellow Brookland attorney Austin Fickling, president the Brookland Civic Association. (AAA.)

As Brookland was growing, so was Rhode Island Avenue and neighboring Woodridge. The Ha Hardware Store at Twentieth Street and Rhode Island Avenue is shown in 1925. This section of Northeast could not have too many hardware stores; with Brookland and beyond full of ne homeowners, many with contracting skills, the demand for materials was high. (LOC.)

Carrie Harrison was employed by the Department of Agriculture as the first woman to travel overseas gathering specimens. In 1903, she built an elegant Spanish-style villa and large greenhouse at 3331 Newton Street. She planted specimens acquired on her many foreign trips. Two Chinese cedars, said to be gifts from the Emperor of China, are still in the front yard. Harrison was a lifelong Republican, suffragette, and friend of President Taft, whom she entertained at her home, along with other luminaries. She employed Thomas Diggs (see page 83, bottom) as a garden helper when he was an adolescent living a block away. (LOC.)

Theodore Holm (also on page 27) returned to Brookland at the end of his life, not to reside, but to work. He had moved to his farm in Clinton in 1903 to conduct botanical research. But in the late 1920s, he accepted a chair in botany from CUA and taught there until his death in 1932, leaving them his herbarium and personal papers. (CUAA.)

Antoinette Margot (left), shown in the 1920s with a friend, lived quite happily across from St. Anthony's church most of her adult life, acting as a sacristan and attending daily mass. Her helper in all Brookland projects, Leonide DeLarue, died from a fall off a ladder while decorating the church for Christmas in the early 1920s. Margot passed away in 1925. (SAA.)

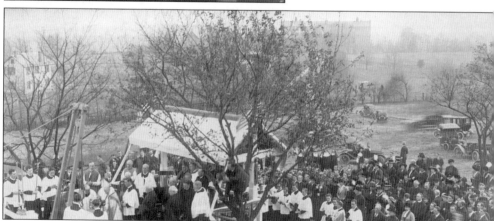

In the foreground is the cornerstone laying at St. Paul's College in 1914 at Fourth and Lincoln Roads. In the background is a large building, St. Vincent's Orphanage (close-up view on page 15) which operated until the mid-1960s, serving not only children without parents, but also acting as a temporary caretaker for children whose mothers and fathers could not provide for them. It was built by the Daughters of Charity on the site of the Edgewood estate. (CUAA.)

A lunch wagon is parked under a shady tree at Thirteenth Place and Upshur Street in 1921. Cars have pulled up to buy a meal. In a neighborhood under construction, carpenters and masons were undoubtedly among the customers. (HSKL.)

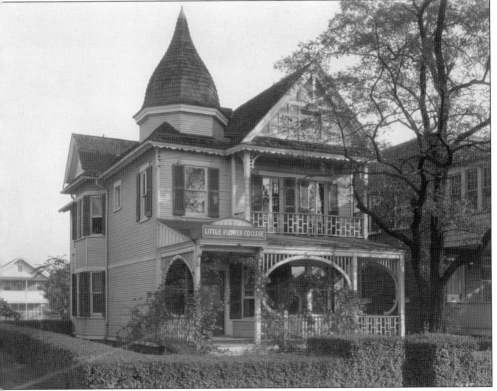

LITTLE FLOWER COLLEGE

This delightful Queen Anne building** made a very inviting house of studies for an order of Catholic religious men. It stood on the 700 block of Monroe Street, just to the west of the tracks, where the Bennett Beauty Academy is now located. Located next door was the Salvatorean Scholasticate (see page 59). (CUAA, Mankiewicz.)

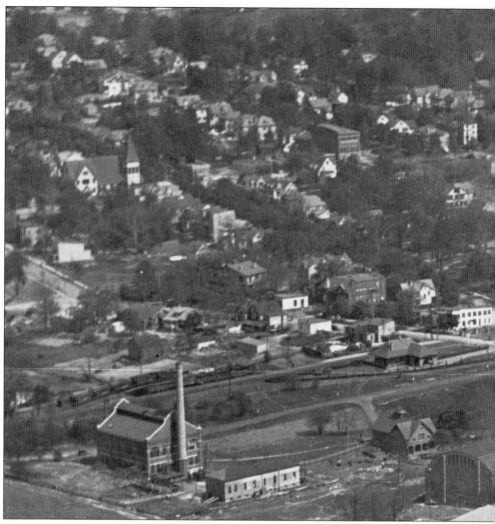

This 1920 aerial view shows a built-up commercial area by the train station. In the left foreground is the CUA power plant and above it with the prominent steeple is Brookland Baptist**, which burned in 1927. Across Newton Street on Twelfth Street is the Hamilton National Bank**, later the location for High's, and then Joe's Minimart. Following Twelfth to the right finds the Renaissance Revival Masonic Hall. In the middle on the right is the University railroad station** on Eighth Street. This is long before the Charles Drew Bridge, so a stretch of homes and businesses, gone today, is visible on Michigan Avenue. (CUAA.)

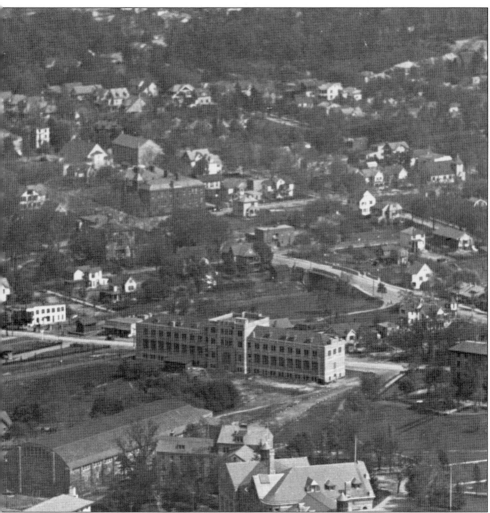

the center bottom is the roof of McMahon Hall on the Catholic University of America campus. Just right of the center foreground is St. Thomas Hall, once Middleton**. Above this is the newly installed Monroe Street Bridge, replacing one of the three previously dangerous railroad crossings. There are homes along the tracks that were later torn down by the B&O railroad. The Brooks Mansion (hidden among the trees near the center, below the Brookland School) has become St. Benedict's Academy. Monroe Street follows a diagonal to the left, and visible is the broad roof of the Brookland School, where Margaret M. Pepper was the principal in 1927. Next, is the original wood-frame St. Anthony's Church** on Twelfth Street. To its right is the parish hall, which remains. (CUAA.)

Marjorie Kinnan Rawlings, the Pulitzer Prize–winning author of *The Yearling*, was born in 1896 and raised at 1221 Newton Street. Rawlings contributed to the *Washington Post* Children's Section and won a prize at age 15 for best short story with "The Reincarnation of Miss Hetty." She left Washington in 1928 and is pictured at her college graduation. (Wisconsin University.)

St. Benedict Academy's graduating eighth-graders are shown in 1921. Betty Cahill Hardy, later the beloved school secretary at the CUA Campus School, is seated in the first row, fourth from left. To her right sits Mar Stock Kelly (also on pages 74, 78, and 100), great-granddaughter of Ann and Jehiel Brooks and the grandmother of *Washington Post* Metro columnist John Kelly. The Bohnert twins are standing just behind the boys, on either side of the third row. Their father owned the village bakery.

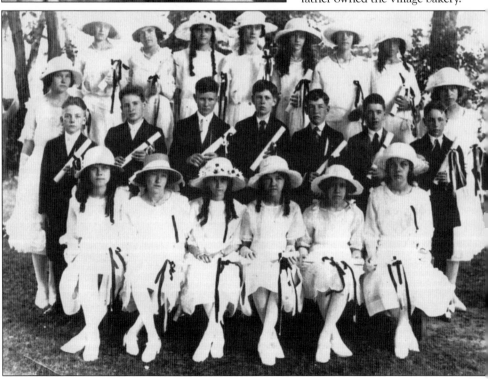

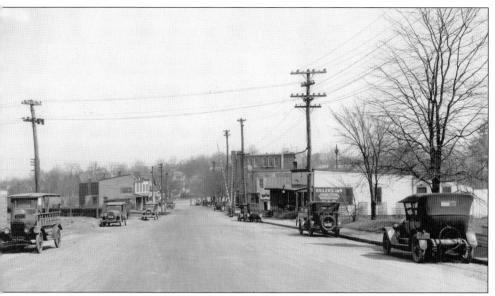

In the years before 1927, the Brookland business district was on Bunker Hill Road (now Michigan Avenue), near the train station. It included a feed store, Heider's grocery, Hailer's Inn, and the original post office**. On Monroe Street, across from Brooks Mansion (where Col. Brooks Tavern stands), there was a barbershop and a cigar store. By 1927, most neighborhood commerce had moved to Twelfth Street. (HSKL, Shannon.)

Shown is the 1300 block of Monroe, looking west in 1925. Little has changed today. The detached row house to the right of the high gabled roof is similar to wooden homes once common in downtown neighborhoods in the 19th century. This row house (built for a maintenance man at the Old Soldiers Home in 1896) is tucked in a block of large Victorians. Nonetheless, all the yards are equally spacious. (HSKL, Shannon.)

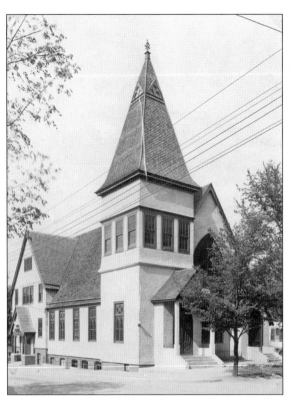

Brookland Baptist Church would have been considered the spiritual and cultural center of early Brookland. With congregants like the Sherwoods, Kinnans, and Marvin McClean (president of the Brookland Citizens Association), it was the place where the most prominent and politically connected residents worshipped. The presidents of the Brookland Citizens Association and the Rose Society, as well as the investment group that built Twelfth Street, were members of the oldest congregation in the neighborhood—dating to 1878. (DCPLW.)

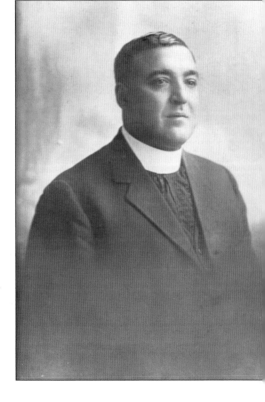

Fr. Pasquale Di Poala was the pastor of St. Anthony's church from 1918 to 1927. St. Anthony's Grade School was established under his leadership. He was a native of Italy and lived in the ground floor of the grade school building, where the delicious aroma of his cooking was a daily distraction. He raised $23,000 to build the school building and the hall. The Italian population in Brookland grew under his leadership.

Newton and Twelfth Streets looks different than it did in the 1890 image on page 20. On the right is Hamilton National Bank, long associated with president James Sherwood. By this era, the empty field on the opposite side of this block was filled with shops. By 1927, this included A.P. Woodson Coal plus two businesses that remain to this day—a delicatessen that is now Murray and Paul's and Brookland Hardware. (HSKL, Shannon.)

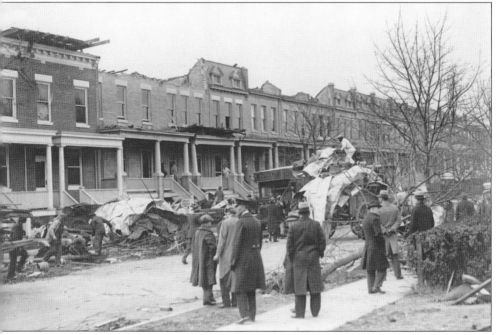

A small tornado touched down on the outskirts of Brookland on May 14, 1927. The funnel traveled from near North Capitol Street in the area of Prospect Hill (a historic German American cemetery established in 1858) over to Rhode Island Avenue and passed over these houses on Thirteenth and Fourteenth Streets. (LOC.)

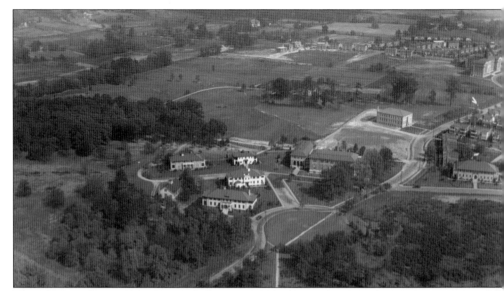

This 1930 aerial view of the Sisters' College campus looks east. Just past the campus is an open field that at the time was the Firman R. Horner dairy farm. Located on Varnum Street, east from Sister College, is the simple, box-shaped Campus School. Past this point is another open field, the future home of Providence Hospital. (CUAA.)

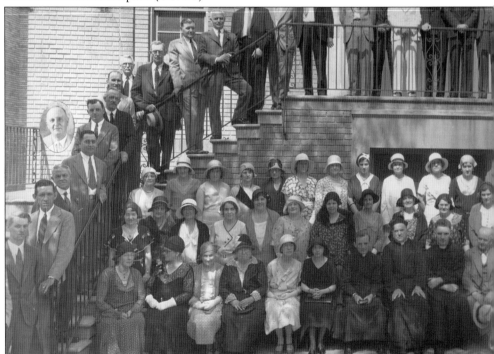

Starting in 1931, this group raised $300,000 to build a new church for St. Anthony's church. First on the left front is Edward Weeks, longtime head usher. Anna Mae Fitzmorris Moynihan is in the second row, seventh from the left. Florence Mattimore McGuire, of the drama society, is in the second row, far left. Standing on the stairs in front of the window, in a light-colored suit, is Thomas Walsh, the builder of the Turkey Thicket apartments and later a realtor. (SAA, Capitol Photo Service.)

Four

BLACK AND WHITE MIDDLE CLASS ASCENDANCY

Residential and commercial development continued throughout the 1930s and 1940s. As more African American families moved into the neighborhood, some blocks saw "white flight." Harlem Renaissance poet Sterling Brown reported that when he bought his home at 1222 Kearney Street in 1935, the for sale signs sprang up over night. Some white groups strived to stop more black families from moving into the neighborhood through the continued use of covenants (with assistance of the Brookland Citizens Association), but a gradual process of greater integration had begun. The black community welcomed the arrival of a group of well-informed political activists connected to Howard University, including John P. Davis and Ralph Bunche. With the opening of Lucy Diggs Slowe Elementary, the founding of Brookland Union Baptist Church, and the founding of their own social clubs (Brookland Garden Lovers Club and many others), African American families were able to experience more of the neighborhood.

African American architects built more than 45 homes in Brookland, mostly for Howard University faculty. Large Irish and Italian families filled the Queen Anne–, Bungalow-, and American Four Square–style homes. Additionally, a few Sears mail order houses, a few ranch-style homes, Georgian Revival, and Colonial Revival properties made the evolution of Brookland's residential housing quite diverse.

By 1936, Fort Bunker Hill and Turkey Thicket were US reservation land, and the former would become a national park. Both locations hosted recreation activities, from festivals and movies to plays performed in an amphitheater, and summer camp. Turkey Thicket, the neighborhood playing field, would become a city recreation facility. The social life of this now mature community included large events, like the annual bazaar at Brookland A.M.E. Church, which displayed 100-year-old quilts; a two-week-long St. Anthony's carnival on open land at Seventh and Monroe Streets; and patriotic fireworks. Such activities made not only the daily newspapers but also the tabloid-size *Brookland-Woodridge Shopper*, which was distributed to many neighborhoods that considered this area the center of the broader Northeast community.

Because of World War II, Brookland's population boomed. Temporary war housing and the first apartment buildings were erected, as were strip malls at Turkey Thicket and at Rhode Island Avenue and Fourteenth Street. Brooklander John D. Walsh constructed apartment buildings and a commercial strip in Turkey Thicket, which historian James Goode judged to be the finest example of an Art Deco strip mall in Washington, DC.

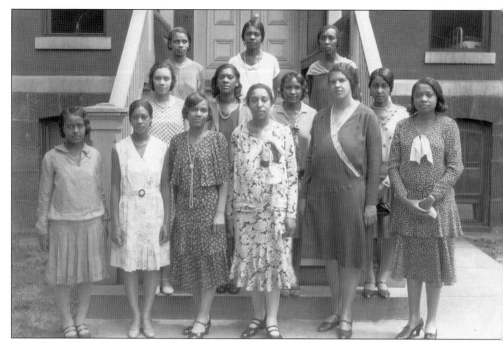

Lucy Diggs Slowe (center) was the first dean of women at Howard University, serving from 192
until 1937. She was a founding member of Alpha Kappa Alpha Sorority in 1908, the first sororit
for African Americans. Slowe was a trailblazer, a mentor for women of color in academia, and wa
a national title tennis champion. She is pictured with deans of women at a summer conference i
the 1930s. (HUA.)

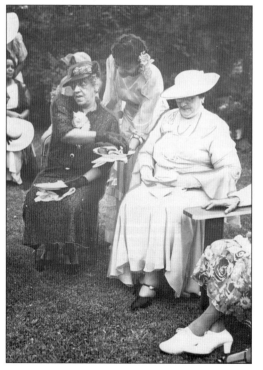

A Howard University senior offers refreshments to Mrs. Miller (left), wife of former dean Kelly Miller, and Mrs. Benjamin Brawley (right), wife of the Howard University literature professor. The opportunity to go to the home of such a celebrated woman made Dean Lucy Diggs Slowe's annual garden party a much anticipated affair. Located at her home on 1256 Kearney Street++, this 1937 party was held for seniors and their mothers. Slowe also hosted the wedding of her assistant Joanna Houston, who married the grandson of Rev. Reverdy C. Ransom, of the same name. Reverend Ransom was a nationally prominent religious leader and pillar of the African Methodist Episcopal Church. (AAA.)

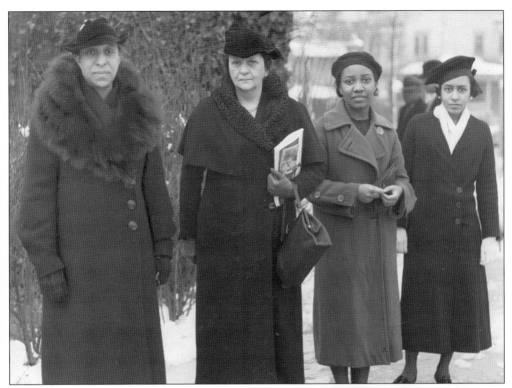

The Franklin D. Roosevelt administration valued Lucy Diggs Slowe's (left) expertise and consulted with her during the Great Depression. Secretary of Labor Frances Perkins is shown in 1937 at Howard University with Dean Slowe and two student leaders escorting her around campus. Many Howard University faculty, including Brookland-born and -raised Robert Weaver, served on federal commissions to address national problems as they related to African Americans. (AAA.)

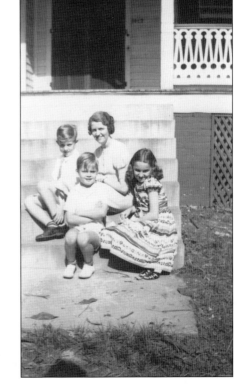

Elizabeth Stock Cahill, great-granddaughter of Ann and Jehiel Brooks and daughter of Leo Stock, sits on the front steps of 1017 Michigan Avenue**—"the big house," as the family called it—in 1937. She is pictured here with her children. Her home was often filled with extended family, many from the neighborhood. (Molly Murray.)

Elizabeth Cahill's sister Mary Stock Kelly and her family lived at Fifteenth and Otis Streets**. Stock cousins (all Brooks descendants), Peter Murray (top center), and his sister Molly (far right) are sitting on the porch of the Stock home. This was a wonderful time to be a child in Brookland. With many empty lots and woods and fields around, children freely explored and played throughout the long summer days. In the 1930s, Brookland parents banded together to turn Fort Bunker Hill into a park space. (Molly Murray.)

This is Agnes Brooks Stock in the 1930s. She was Brooks's granddaughter and the wife of Leo Stock. Her descendants continued to live in Brookland until 2005. Her daughter's home abutted the grounds of the Franciscan Monastery; the north side has barely changed since 1900, with 40 acres of fields, the greenhouse, and the cemetery all still there. (Molly Murray.)

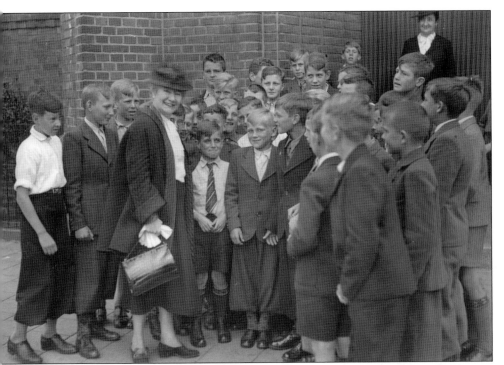

ustine Ward is on a trip to Holland to promulgate her musical method. The Ward method is used throughout the world today. Ward lived at 1326 Quincy Street, the house built for Doctor Shields, and was his biographer. She planned to use St. Anthony's as a laboratory school but was not encouraged by the principal. At CUA, she was given the opportunity to train teachers in her method. Ward Hall, on the CUA campus, is named for her. (CUAA.)

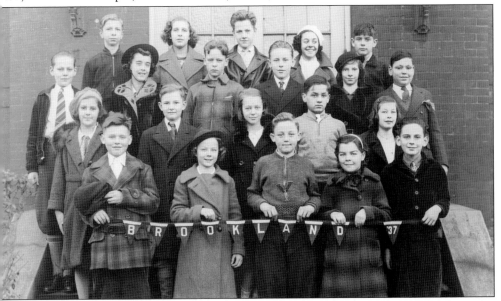

In 1937, Brookland Elementary was one of many grade schools, which also included Noyes, John Burroughs, and Bunker Hill—all public schools for white families. Also, there were St. Anthony's and the Catholic University Model School (also called Campus School). (SSMA-HW.)

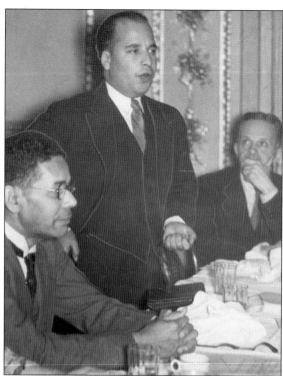

Native Washingtonian John Preston Davis was a civil rights activist and Harvard Law School graduate who lived at 3200 Fifteenth Street. He played cards at Harvard with classmates Ralph Bunche and Robert Weaver (a native Brooklander). In 1933, Davis was instrumental in founding the Joint Committee on Economic Recovery to address the needs of African Americans during the Great Depression. He founded and published *Our World* magazine, the precursor to *Ebony* and *Jet*. (AAA; photographer Scurlock Studios.)

Howard Mackey, born in 1901, was one of the premier African American architects in Washington throughout the first half of the 20th century. He taught at Howard University from 1924 to 1968. Mackey built homes in many architectural styles throughout the neighborhood. Other Howard University–affiliated African American architects who designed dozens of houses in Brookland included Oliver Cassell and L.W. Giles. (HUA.)

Dr. Roy J. Deferrari taught classics and acted as an administrator at CUA from 1918 until 1960. In 1918, he began advising George Morton Lightfoot, a master's degree candidate, in classics. In 1922, Deferrari was told that Lightfoot, though qualified, could not graduate with his class because he was black. This injustice rankled Deferrari, and he became an advocate for racial equality in Brookland. Through his efforts, CUA reopened is doors to African Americas in 1936. (CUAA.)

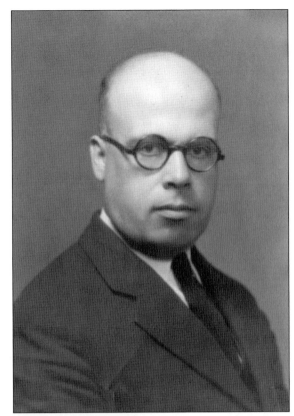

The Brookland Citizens Association urged construction of a nearby junior high school in 1927, soon after the advent of junior high schools in the city. The building, named for Pres. William Howard Taft, was constructed in 1933. Many Brookland events were held on its playground, including the 1939 Fourth of July celebration, which included the married women's race and necktie tying contests. (SSMA.)

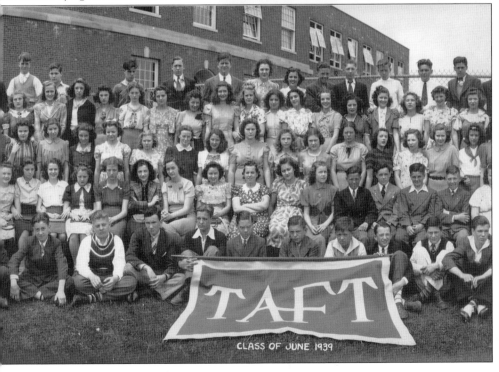

CLASS OF JUNE 1939

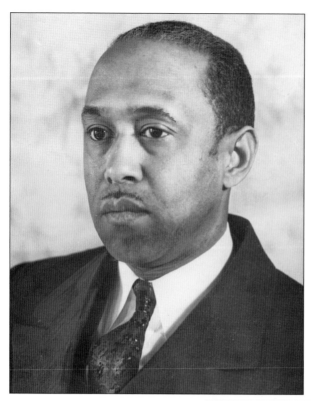

Dr. William T. Grady was one of the rising professional men of color who joined university faculty members as residents in Brookland in the 1930s; the rising professionals were frequently Howard University alumni. Grady was president of the Brookland Civic Association in 1938. The association advocated for services and equality for African Americans. Grady was a dentist and active in the National Dental Association, a professional organization for minority dentists. (AAA.)

John W. Lawlah, shown with his family in their Brookland home, was the dean of the Howard Medical School from 1941 to 1945 and on its faculty until 1974. He lectured in radiology and was director of Freedmen's Hospital. He was inducted into the American Roentgen Society, the first African American to be admitted to that international scientific forum for the study of radiation science. (AAA.)

Brookland Union Baptist Church, first a home church, sat on the site of its current building at Fourteenth and Irving Streets. In 1945, Shiloh Baptist, a downtown congregation, commissioned assistant pastor Rev. Joseph A. Miles to start a mission in Brookland, which established a Sunday School for African American children. In 1947, Reverend Miles and 12 members organized the mission into an official Baptist organization. In time, the congregation would build a new tan brick church. Miles was active in the Upper North East Ministry Council, which encouraged cooperation among area churches. He sought to enrich the life of the Brookland community by supporting service groups, including the Brookland Friendly Neighbors club, the flower club, and a nursery school. Brookland Civic Association and Brookland Progressive Business Association were always welcome to use the facility for meetings. (Both Brookland Union Baptist Church.)

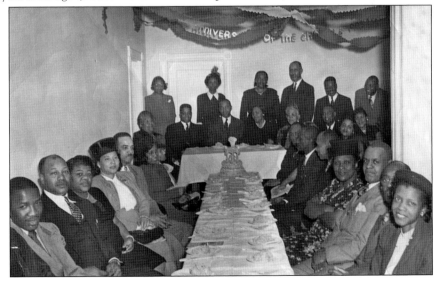

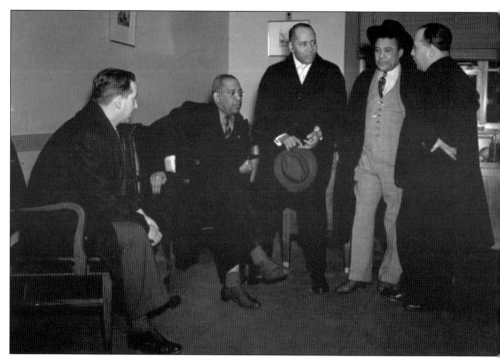

In 1943, John P. Davis, of Fourteenth Street, brought the first lawsuit challenging school segregation in Washington, on behalf of his five-year-old son. While there were five elementary schools in Brookland, there were none for the 500 black families here. Although Davis's lawsuit failed in court, it resulted in the opening of the Crummel Annex School in a bungalow in the 3100 block of Fourteenth Street. Above, Davis (far right) meets with fellow civil rights activists, including attorneys Charles Houston (seated, center) and J. Finley Wilson (next to Davis). The black community continued to demand an adequate facility be provided by the school board, and ultimately, Lucy Diggs Slowe School was built at Fourteenth and Jackson Streets to serve them in 1948. A second story was added in 1951. (Above, AAA; below, SSMA-HW.)

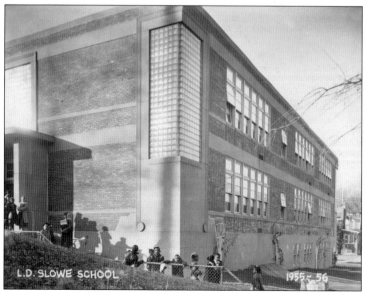

Pictured from left to right, Mary Church Terrell, Mary McLeod Bethune, Nannie Helen Burroughs, and Dr. Sara Brown were educational titans of their era. They are shown arriving for Dr. Kelly Miller's funeral in 1940, at Howard University's Rankin Chapel. Terrell and Bethune founded the only school open to African American children in Brookland in the early 1900s. Kelly Miller's wife is shown at Lucy Diggs Slowe's garden party on page 72. (AAA.)

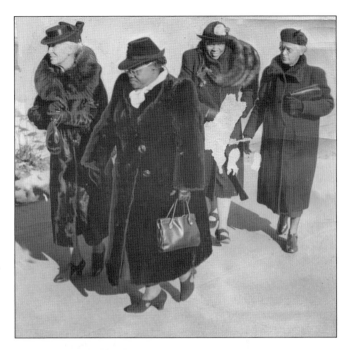

Born in 1901, Sterling Brown followed his father to Howard University as a faculty member and taught literature for 50 years. Ralph Bunche was among his students. In 1935, Brown moved to 1222 Kearney Street. He published *Southern Roads*, his first book of poems, in 1933. A sign++ erected by the DC Commission on the Arts and Humanities commemorates where he lived for the remainder of his life. (HUA.)

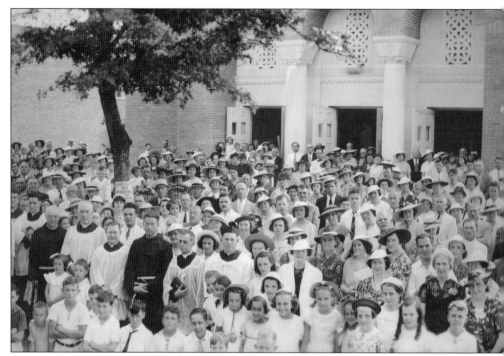

On June 26, 1938, the parishioners of St. Anthony's turned out for the laying of the cornerstone of the structure that still stands at Twelfth and Monroe Streets. The entire scope of St. Anthony's ethnic makeup was represented by Irish, German, Italian, and African American faces in the crowd. Various clergy also came—a Franciscan stands near the tree to the left. (SAA, Capitol Photo Service.)

Columbia Harmony Cemetery, located at Twelfth Street and Brentwood Road, was the first African American cemetery in Washington, DC. It was founded in 1893. Among those buried there were a number of Civil War veterans. In 1959, the graves were disinterred and moved to National Harmony Memorial Park in Largo, Maryland, by the city. Out of concern for how this removal was accomplished, Brooklander Vivian Ashton maintained that some Civil War veterans were still buried at the site after a district impoundment lot was built there (now Home Depot and Giant). (AAA.)

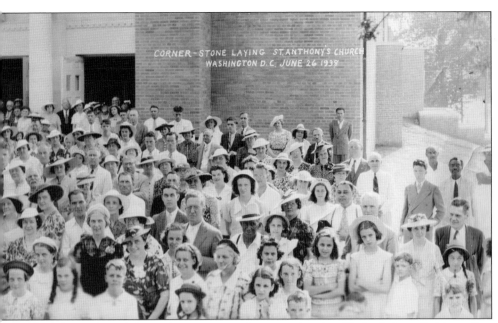

To the far right are three African Americans standing apart (see detail below). A small girl standing sixth from the right in the second row, Anne Fitzpatrick, looks curiously at the camera. She grew up on Twelfth Street, married James Neville, and had seven children (one of whom we see as a Cub Scout on page 112). The family lived at 1005 Shepherd Street. (SAA, Capitol Photo Service.)

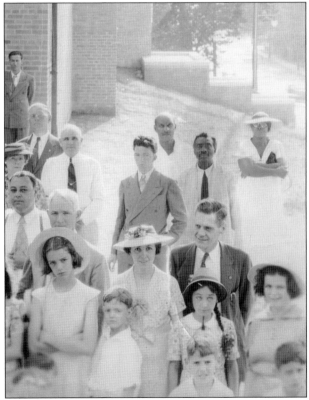

John Diggs (far right) stands to the left of his wife, whose arms are crossed. Though their children have received the sacraments at St. Anthony's and attended mass here for 20 years, they stand apart at this parish gathering. Segregated seating was still part of worship at St. Anthony's. The Diggses lived at 1351 Otis Street in a house built by the father. Today, the youngest son, Thomas Diggs, lives next door to his childhood home in the house he built. (SAA, Capitol Photo Service.)

In 1939, Fr. Henri Hyvernat is still poring over ancient texts at age 81. He built CUA's Semitics program over five decades, along with amassing a world-renowned collection of texts and artifacts. He established the university's leadership in Coptic studies and Assyriology. His wide circle of friends and colleagues made his home on Twelfth Street (where the post office now stands) a hub of activity. (CUAA.)

Looking north from Twelfth and Monroe Streets in 1947 reveals that the Brookland Baptist Church is gone and instead a temple of art—the Newton Theater—stands in its place. Jesse Sherwood Jr., following in his father's footsteps as a developer, built the theater in 1937. Trolley lines are overhead, just as they were in 1927, and all the shops are still in place. (HSKL, Wymer.)

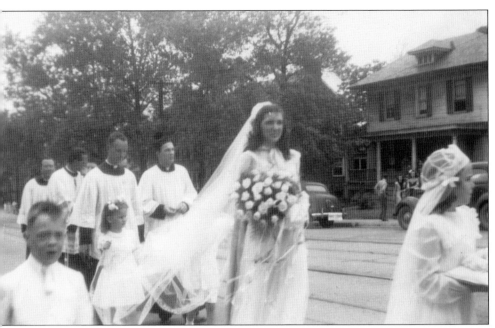

amily and friends line the street in 1941 as St. Anthony's church and school participate in their nnual May procession. A religious ritual that took place every year for decades, seven-year-olds rocess up the 1000 block of Monroe Street—the girls in white veils and dresses and boys in white nirts and black pants. Altar boys carry the censer, incense, and cross as the procession moves toward pilgrim statue of Mary in the church parking lot. There, an eighth-grade girl, who has been given ne singular honor of crowning Mary, will place a circle of flowers on the statue's head as "Immaculate Iary" is sung. Pastor "Dr. Coady" follows at the end of the procession. He insisted on being called Or. Coady" because of his PhD. (SAA.)

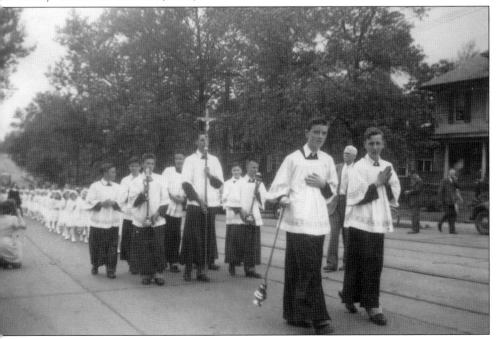

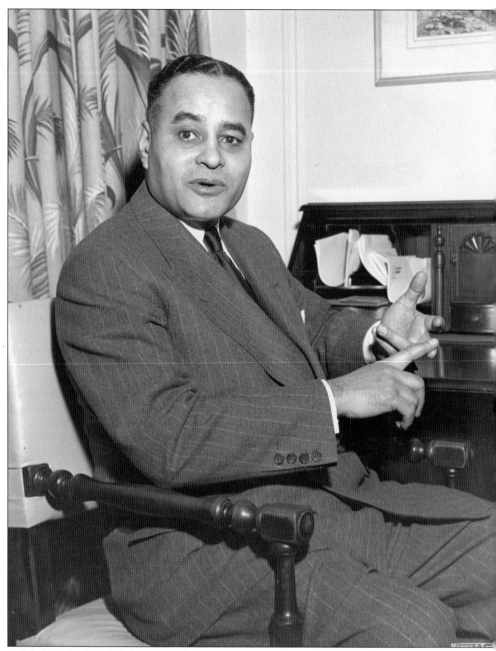

Ralph Bunche founded the Political Studies Department at Howard University in 1928 and taught there until 1950. Bunche had many ties to Brookland, including Harvard classmates who lived nearby. Fellow faculty members, including Sterling Brown, also lived nearby. Once Bunche began his work for the United Nations, his family moved to New York in 1947. In 1950, Bunche became the first African American to receive the Nobel Peace Prize. (AAA.)

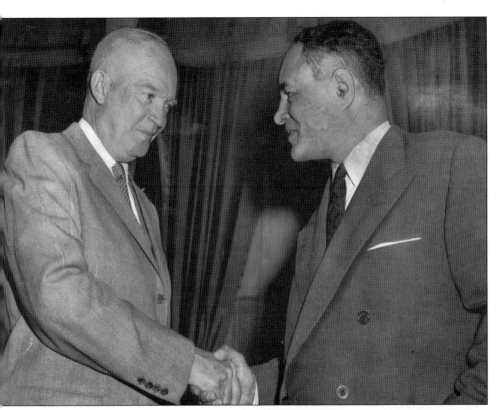

In 1958, when asked what he thought of Washington, Ralph Bunche replied, "I lived there for 15 years . . . My kids had to go to segregated schools. I had to send them clear across town from Brookland to the nearest colored school . . . I could not go to the movies, hotels, or restaurants." Bunche discovered that even pet cemeteries were segregated in Washington. Jim Crow laws made the move to New York increasingly appealing. (Associated Press.)

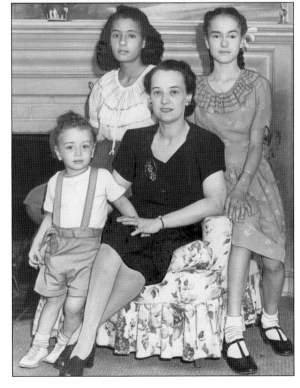

The Bunche family lived at 1510 Jackson Street++ from 1941 to 1947. This was a happy time for Bunche children Ralph Jr., Joan, and Jane. Years later, Joan reported to Brian Urquhart, her father's biographer, that because of her father's regular work hours, he was able to spend many hours with his children during their Brookland years. Like his father, Ralph Jr. became a diplomat at the United Nations. (DCPLW.)

Simple lines, geometrical forms, a flat roof, and an asymmetrical facade characterize this International-style home designed by Hilyard Robinson for the Bunche family. Unlike the Georgian or Colonial Revival houses common in the 1940s, the International style eschews references to the architectural past. International-style homes are seen throughout Brookland. The Bunche house++ was designed with a back deck overlooking a typically spacious Brookland backyard. (GWA-GM.)

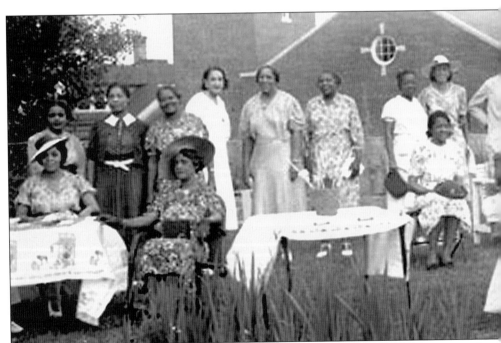

In 1940, the Brookland Art Club meets at 1325 Franklin Street. Lawn and garden parties were always popular in Brookland where yards were large, breezes were cool, and the company was congenial. The Brookland Friendly Neighbors club was founded at about this time. It hosted annual block parties

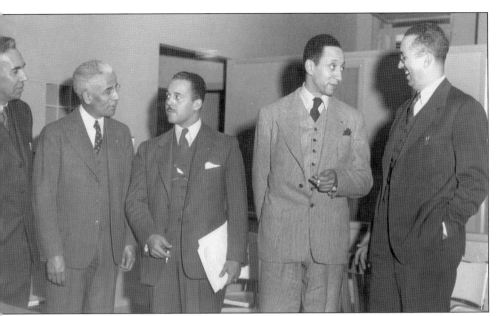

ilyard Robinson, second from right, is meeting with fellow Howard faculty members in 1949. Robinson as a proponent of the International style, but he also designed Brookland houses in historical revival yles, usually Federal and Georgian. He designed several houses in south Brookland for the Howard niversity community besides the Bunche home. These included 1519 Jackson and 1305 Hamlin. lways dapper, he was featured in advertisements in 1952 for Lord Calvert Whiskey, which ran in ⟩-called Negro magazines. (HUA.)

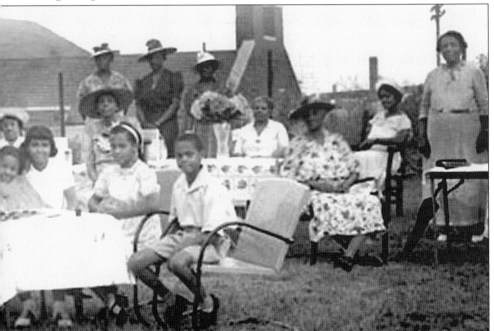

elcomed new neighbors, and sponsored block cleanups for more than 50 years. In the background, he roof of Noyes Elementary School is visible. This raised land was later leveled. (LOC.)

Pearl Bailey lived at 1428 Irving Street during her 1948–1951 marriage to John Pinkett. Bailey's singing career began in jazz clubs in Washington prior to joining Count Basie's Orchestra. She also sang with Duke Ellington. Her divorce from Pinkett was headline news because she accused him of physical abuse. (HUA.)

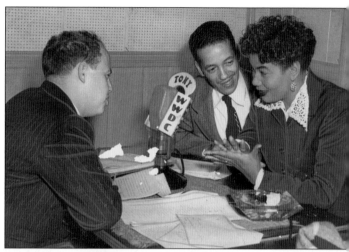

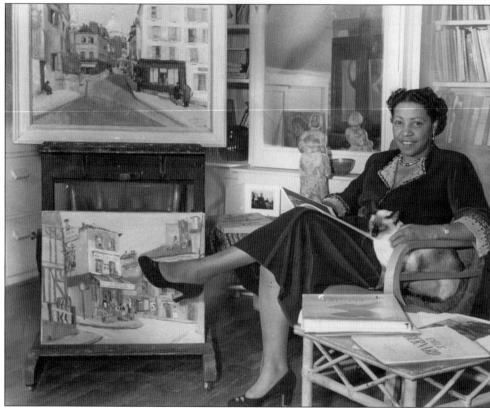

Lois Maillou Jones was a painter, illustrator, and muralist, who taught at Howard University from the 1920s until her retirement in 1977. She lived at 1220 Quincy Street++ for decades. She had her studio in her home, under the skylights at the back of the house. She was born in Boston in 1905. In 1937, she went to Paris on sabbatical from Howard University. This began her love affair with the City of Lights. It was in Paris where she developed her African-influenced style and her sure use of color. Her works are in major collections across the country, including the National Gallery and the Metropolitan Museum of Art in New York, as well as in the Louvre in Paris. She lived until 1998. (DCPLW.)

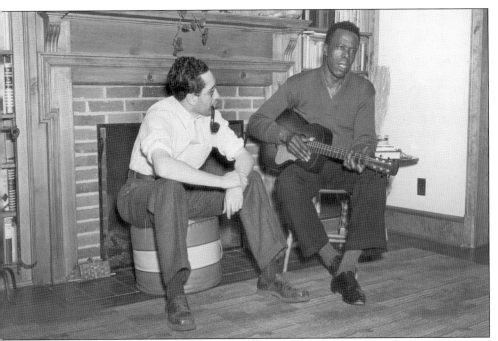

terling Brown's (left) poetry drew upon his appreciation and ear for African American music, articularly the folk songs and blues of the Deep South. He is shown in his Kearney Street living oom with "Big Boy" Davis, the subject of many poems in his first book, *Southern Roads*. Brown had strong influence on his students, who included Toni Morrison, Stokely Carmichael, Ossie Davis, nd Amiri Baraka. (HUA.)

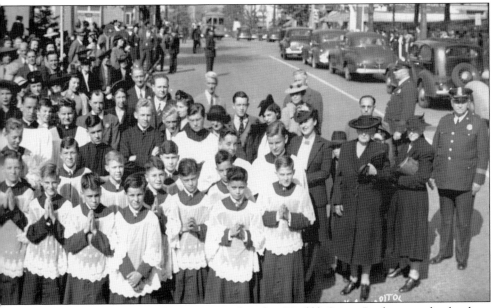

is 1945, and St. Anthony's parishioners are gathered on Twelfth Street. Looking north, altar boys ll the first row. Dr. Coady, the pastor, made youth a priority for the parish. Every Friday he opened he parish hall for Chi Ro gatherings, where teenagers played ping-pong, sang, and challenged one nother to checkers and chess. (SAA.)

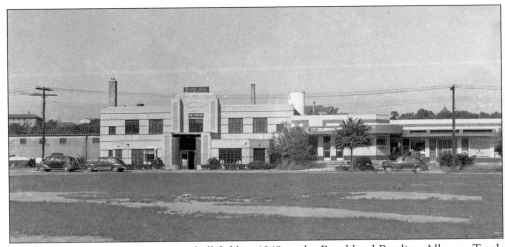

Viewed from the recreation center's ball field in 1948, is the Brookland Bowling Alley on Tenth Street. There were many recreation opportunities for the white population throughout this period. The open field that became the recreation center had long been the site for neighborhood baseball and pick-up football games. Today, Atlantic Electric occupies this building. (HSKL, Wymer.)

Marianne Kerins is shown here on her porch at 1014 Perry Street. Behind her is the southern end of the Turkey Thicket playing fields. The fields got their name from Nicholas Queen's property, Turkey Thicket, though the name goes back much further than his time. There was a swimming hole on the site of the current tennis courts. Boys' teams played on these fields since the turn of the 20th century. Neighborhood pickup games eventually were organized into league play for baseball and football. After the city recreation department acquired the land, in the early 1950s, basketball courts were added and a new era began in Brookland. An apartment building now blocks the view shown.

The trolley is full as the Tractioneers Club goes on one of its regular outings. These trolley aficionados left a rich record of their beloved trolley system. They sponsored runs of old model trolleys and shared trolley lore. Trolleys were phased out by the 1960s. But with new talk of a cross-town trolley system, it seems their day has dawned again. (HSKL.)

The 80 bus has taken many Brooklanders downtown and back through the years. Anyone who wanted to get to the central shopping district (to F or G Streets, where the record and department stores were) had to take the 80. Just as the Metro station is a place where Brooklanders meet on their way downtown today, so was the 80 bus and its terminus years ago. (DCPLW.)

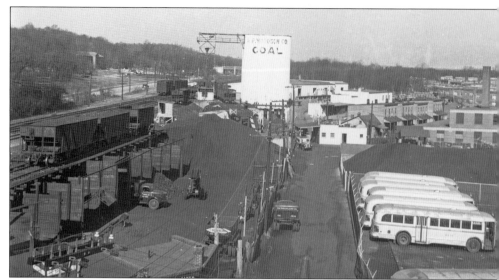

This is a view of the Metropolitan Transit Company bus lot and garages, located behind the Brooklan
Bowling Alley on Tenth Street. Beyond the lot, on the far right, is the Turkey Thicket Apartment
They were built by Thomas D. Walsh, depicted on page 70. These four-unit buildings were popula
with faculty, graduate students, and families from the 1930s to today. Walsh went on to become
citywide realtor. (HSKL, Wymer.)

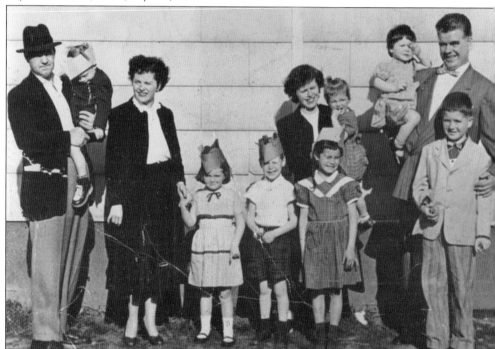

During World War II and in the postwar years, housing in Washington was at a premium. The
federal government built temporary housing to meet this need. A total of 90 housing units around
common courtyard lawn filled what had been an empty field next to Dominican House at Seventh
and Monroe Streets. Many families of returning servicemen lived there. Pictured are three familie
all related through the Kerins sisters, whose descendants still live in Brookland.

In 1950, what is now called Oak Terrace Condominiums on Twelfth Street, was Donald Hall, residence for the CUA graduate students. Later, in the 1970s, the university used the Newton Theater as a performance space for the music school. While religious orders own many properties in central Brookland still, the university has concentrated its properties on the west side of the tracks. (CUAA.)

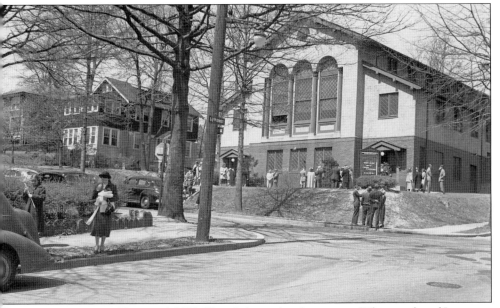

This is a 1940s picture of Bunton A.M.E. Church, located at the corner of Thirteenth and Lawrence Street. Joseph Wymer, the photographer, noted in his album what a well-maintained and pleasant integrated neighborhood Brookland was in those days. The congregation is leaving services. The black population continued to grow throughout this period because of the long history of black landownership in Brookland. (HSKL.)

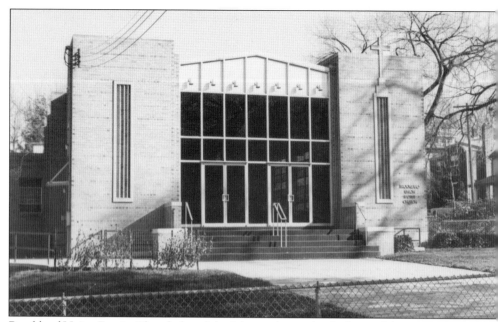

Brookland Union Baptist Church demolished the row house that had served the congregation for 2 years and began to raise funds for a new church. Members worshipped at Lucy Diggs Slowe Elementar for two years. By 1962, the congregation was able to break ground at 3101 Fourteenth Street—an will celebrate its 65th anniversary in 2012. The church acquired more property later and named cultural center for Reverend Miles. (GWA-GM.)

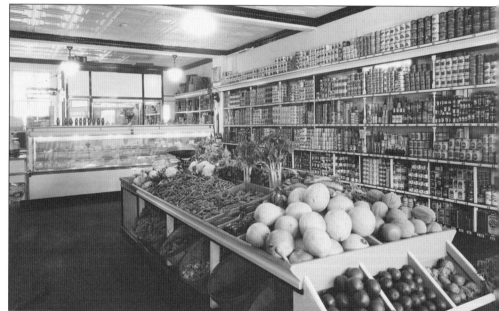

Corner markets were found throughout Brookland. The Sanitary Grocery chain had a shop in th 3400 block of Twelfth Street. There were other independent stores every few blocks. This is a Distric Grocery Store franchise at 3925 Twelfth Street**. Notice the tin ceiling. Like almost the entire stock of Twelfth Street commercial buildings, this shop is one story, one large room, and designed as a shop for an owner-occupant. (LOC.)

Group houses have long been a feature of the Brookland scene. Here a group of CUA students in 1948 are having a potluck in their common dining area—the basement. They will do their clean up in laundry sinks and then dance. Housing is still at a premium in postwar Washington, but everyone appears to be having a good time making do. Ellen McNulty, a nursing student at CUA, is seated in the foreground, right.

Here is the academic Martin D. Jenkins playing ping-pong in his Brookland basement. The current enchant for finished basements was not shared by the previous generations. Jenkins had a distinguished career in the Maryland university system, and undoubtedly socialized with Howard University faculty who also lived here. He was president of Morgan State College from 1948 to 1970. (AAA.)

Here are four CUA roommates on the steps to their apartment at 1282 Lawrence Street. Ellen McNulty is shown again here, standing at the bottom of the stairs. She went on to join the nursing faculty at CUA in 1972. She and her roommates rented from Catherine Noelle, the president of the Brookland Citizens Association. Noelle grew up in Brookland and led the citizens association to fight for street improvements, support civil defense during World War II, and fight integration. Brookland Citizens Association members opposed integrated recreation facilities and public housing projects and supported block covenants to restrict black home ownership.

With an ambitious design based on rambling one-story schools in California, the Burroughs Scho went up at Eighteenth and Monroe Streets as funds became available between 1916 and 1927. Name for John Burroughs, a writer and teacher who lived in Washington from 1863 to 1873, it is the on DC school built in this manner. The school was slated to transfer to the colored division but halte when general desegregation came to fruition in 1955. (SSMA-HW.)

Father Dressel was the moderator for these Catholic Youth Organization (CYO) 1947 city baseball champions. The CYO sponsored teams in all sports, raised money for equipment and uniforms, and gathered a dedicated group of volunteer coaches, like long-serving Al Luciani. Jack Sullivan played ball at Turkey Thicket Playground and for the CYO. A 1950s St. Anthony's basketball star, he became a Mount St. Mary's College record-breaking scorer. (SAA, Shields.)

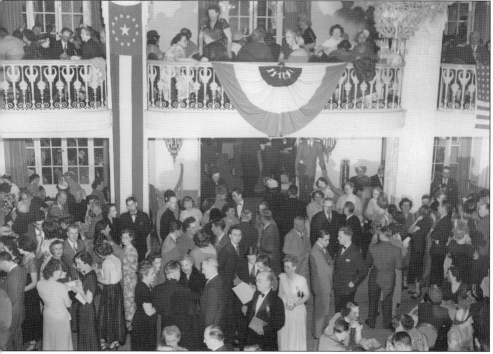

The Mayflower Hotel is the scene of this St. Anthony's card party fundraiser. Many large events in the Catholic community were held at the Mayflower. Bingo had not yet become a regular fundraising event at St. Anthony's, but large bridge game parties were popular. This annual event was strongly supported by the community, and the proceeds were dedicated to St. Anthony's High School building fund. (SAA, Shields.)

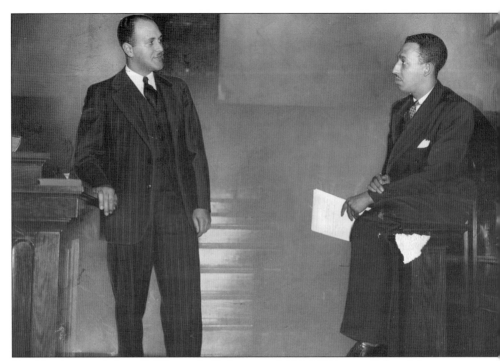

Brookland native Robert C. Weaver (left), shown with NAACP lawyer Robert Ming, was sworn i as the first African American appointed to a cabinet post. He took the oath of office as Secretary Housing and Urban Development at a White House ceremony in 1966. Weaver grew up in Brooklan at 3519 Fourteenth Street Northeast**++, where his father was a postal carrier. (AAA.)

This striking International-style home, located at 2824 Fourteenth Street was built by Howard I Mackey for the C.C. House family. It stands high above the street on a terraced lawn, overlooking Irvi Street. While continuing to lead Howard University's architecture program—the first predominate black school of architecture to be accredited—Mackey served in professional organizations and design 10 residences for black professionals in Brookland during the 1930s and 1940s. (GWA-GM.)

Five

NEIGHBORHOOD IDENTITY AND CITIZEN ACTIVISM

The Supreme Court ruling in *Brown v. The Board of Education* (1954) mandated integration in Washington. All Brookland institutions had to deal with the question of racial integration; St. Anthony's elementary and high schools had already integrated in 1953 and the public schools followed in 1954. Recreation facilities, including Turkey Thicket, integrated shortly after the judgment in 1955. Businesses, including the trolley company, were slower to respond. African American entrepreneurs, including most notably the Johnson family, bought commercial property and built businesses on the 3600 block of Twelfth Street. Sunset Cleaners and the Brookland Florist were early African American–owned enterprises. Groups, such as the Catholic Interracial Council, organized sit-ins at the People's Drug Store lunch counter during the 1960s. Customer lobbying brought about the integration of the Newton Theater in the mid-1960s. Brookland evolved into a stable, racially mixed, middle-class neighborhood, with the added town-and-gown element of several nearby colleges and universities.

This era ushered in a period of great basketball on the courts of Turkey Thicket. Many boys who played there would go on to be high school and college stars, and even professional players. Neighborhood resident Jack Sullivan was a high scorer at St. Anthony's High School who broke records at Mount St. Mary's College. Future Notre Dame president Edward J. Malloy, nicknamed the "Mayor of Turkey Thicket," introduced Carroll High teammates John Thompson and George Leftwich to his favorite courts in the Thicket. Neighborhood children who honed their basketball skills there included Mackin High All-Met Tom Little, McKinley High All-Met Jeffrey Bossard, Georgetown player Merlin Wilson, and John Battle, of the Atlanta Hawks and Cleveland Cavaliers. Aspiring tennis aces came out to the Thicket for tips from Robert "Whirlwind" Johnson, a McKinley High School teacher—and Arthur Ashe's former coach.

In the 1970s, new institutions moved to Brookland. Contributing to the growing nonprofit community were the Center for Concern, Guildfield Baptist Church, Anchor Mental Health, Deaf Reach, Mary House, Sojourners, and Catholic Charities.

In the same decade, Brooklanders were in the forefront of the fight to stop the Interstate 95 freeway, which threatened to bulldoze many homes near the tracks. The Brooks Mansion was saved, but the beautiful old train station was demolished to make way for the new subway station. As the community rallied to preserve its historic landmarks, Brookland became an even larger transportation hub.

In spite of the constant shifts of modern life, Brookland remains a wonderful place to live: a village-like neighborhood, ideally located in one of the world's great cities, with a truly diverse and vibrant population. It is rich in open spaces and steeped in an enduring sense of place and history.

This sign was a Brookland icon for more than 30 years. Italian immigrant Pietro Dastoli ran his shoe repair business at 3506 Twelfth Street. When his retirement years were approaching, he sold the building and continued to work as a renter. He wanted to keep his building and business in the family, but his son did not want to be a cobbler. Today, his property belongs to the development company Realm Incorporated. (CUAA.)

Brookland Barber Shop and Brookland Shoe Repair, located at 3506 and 3508 Twelfth Street, respectively, have been at their locations on the Brookland commercial strip since 1920, when they were built. These two businesses, in particular, are establishments where former residents return to regularly to keep up with the old neighborhood. A restaurant has been in Murray and Paul's location across the street since 1927. (GWA-GM.)

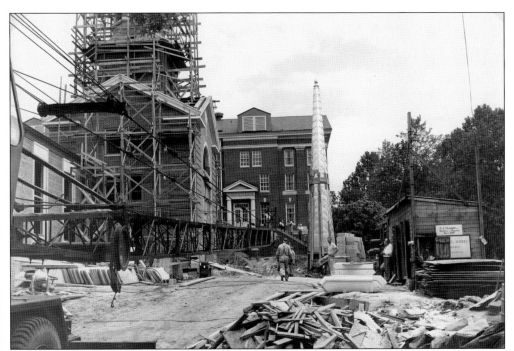

In 1927, the original Brookland Baptist Church at Twelfth and Newton Streets burned, and the congregation moved to 3420 Sixteenth Street. This was the third location of a congregation that began in 1878 at Michigan and South Dakota Avenues as an outdoor religious meeting in a grove on the Lord farm. In 1950, after a two-decade fundraising campaign, a Georgian Colonial sanctuary and chapel were constructed and connected to the Sunday school that had been built 30 years before. Brookland Baptist Church was a 1,200-person congregation at its height. Yet, it would sell its property and move away because of fear of integration, in a phenomenon known as white flight. The pastor Rev. Ward B. Hurlburt and his wife worked diligently to get their congregation to accept integration through interracial dialogue. However, their efforts did not succeed, and the seventh-largest Baptist congregation in the city ultimately left for Riverdale, Maryland. (DCPLW.)

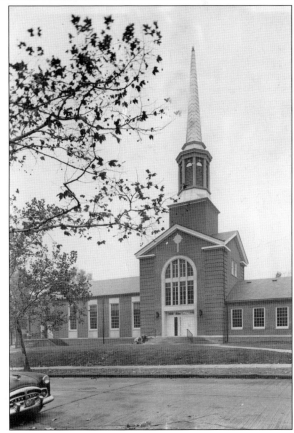

Located at Sixteenth and Monroe Streets, this 100-room Sunday school was built by the Brookland Baptist Church. The seminary class of 1950 is standing on the steps with pastor Rev. Ward B. Hurlburt (fourth from left, back row). Integration became a difficult issue for many congregations. Brookland's Episcopal and Catholic churches had an easier time retaining parishioners because African Americans had been attending them all along, albeit in segregated seating. (DCPLW.)

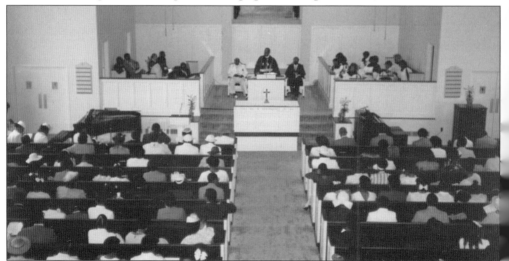

St. Paul Temple Church of God in Christ, a black congregation, bought the former Brookland Baptist Church buildings nearly 40 years ago. Founded by Rev. Warren G. Crudup Sr. and his wife, Parthenia, St. Paul's (not related to the Rock Creek Church) moved to Brookland from Southwest Washington, DC, in 1973. Like Brookland Baptist Church, other white congregations sold their churches to African American congregations and moved away. (Carlton Crudup.)

Reverend Crudup worked for the US Postal Service before answering the call to ministry. He received his training in Washington from Bishop Kelsey and began his work with the St. Paul congregation in 1955. In the beginning, he reached out to the Brookland community by canvassing door to door. In 1988, he was appointed the District of Columbia jurisdiction prelate of the Church of God in Christ and consecrated as a bishop. (Carlton Crudup.)

Father Dressel, of St. Anthony's, is shown front and center in 1954 with the girls' first communion class, including a few African Americans. In the late 1940s, a number of African American Catholic families joined St. Anthony's, and with encouragement from parishioners, such as Adele Kinzelman and Roy Deferrari, they began to take a more active part in the parish organizations and parish social life. The families of Joseph and Robert Quanders were among these. More than a dozen Quanders make Brookland their home still. The Quanders clan is the oldest documented African American family in America, and they have been residents of the DC area for 327 years. (SAA, Shields.)

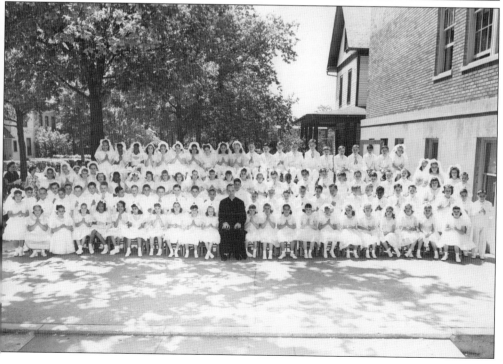

Rayford Logan (second from left) stands with a group on the Howard University campus, where he began his career as assistant to historian Carter G. Woodson. In 1942, he became the chair of the history department and led it until his retirement. He was a civil rights activist, prolific author, and speaker, who lived at 1519 Jackson Street++ (the same block as Ralph Bunche) in a Hilyard Robinson–designed home. (HUA.)

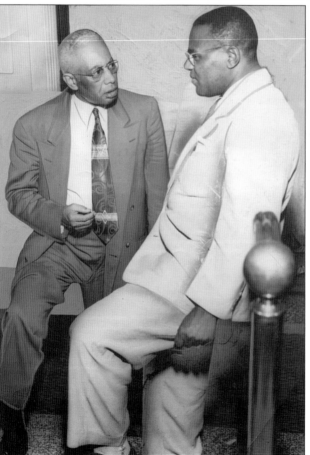

Ellis Knox's (left) 1931 doctorate degree, from Berkeley, was the first one awarded to an African American on the West Coast. With his degree in history and philosophy of education, he accepted a position at Howard University and settled with his wife in Brookland that year. Here he talks with Dr. Earl C. Jackson, of Morgan State College. (AAA.)

In 1952, the first acknowledged African American to graduate from Trinity College was Harriet Parker, from Chester, Pennsylvania. Two women from Brookland were also among the first African Americans to graduate from Trinity. Frances Carter (below) graduated in 1957, and Sylvia Washington graduated in 1958. After her graduation from Trinity, Washington earned a doctorate degree in French from Fordham University, taught in the French Department at Trinity from 1961 to 1967, and then spent several decades teaching at the University of Dakar in Senegal. She returned to Washington, DC, and lives in Brookland.

HARRIET PARKER

Chester, Pennsylvania

In 1965, Trinity's African American population greatly expanded, aided by a Carnegie Corporation grant, which funded 19 students with a yearlong scholarship. Trinity graduates include House Minority Leader Nancy Pelosi, Health and Human Services Secretary Kathleen Sibelius, and Chancellor of the New York City School System Kathleen Black. Today, Trinity is a university with a liberal arts women's college that also accepts men in undergraduate and graduate programs in education and professional studies. The Sisters of Notre Dame De Namur still teach at Trinity and once also taught at Campus School (see pages 70 and 110) on the other end of Brookland. (TUA.)

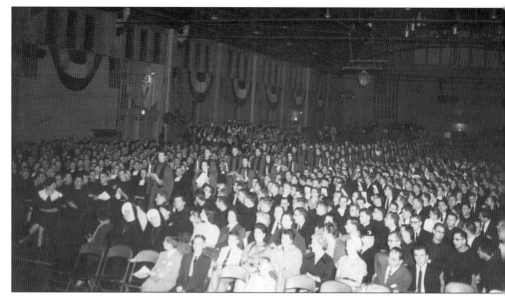

This photograph shows one annual event that attracted a large town and gown crowd—the Catholic University of America Christmas concert. In 1950, it was held in the gym. The variety of religious habits pictured shows the houses of studies and convents were well represented. Some children of the faculty were also present. The popularity of these concerts required anyone who wanted a good seat to arrive early. (CUAA.)

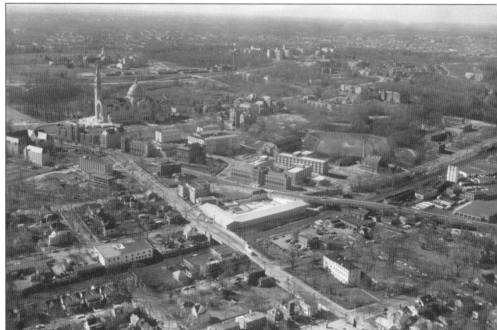

This 1962 aerial shows the Holiday Inn, the U-shaped building with the white roof, beside the railroad tracks. It served the community into the late 1970s. It had an outdoor pool and a lounge frequented by students and neighborhood residents. Eventually, CUA acquired it and maintained it for student housing until 1983. Below and to the right of the inn is the white facade of the Brooks Mansion. (CUAA.)

Turkey Thicket Recreation Center was a hub of activity for families during the 1950s and 1960s. This 1958 photograph shows Mary Gaines, the center director, hugging the May Queen, Jeanie Carlton, and her reportedly disappointed boy friend, who thought that he should be May King. Baby contests were another popular mid-century event in the Thicket. In 1939, Davis "Pop" Volper was the recreation director of the Turkey Thicket Boys Club. In recent decades, Shirley Debrow was the well-loved center director. Sports writer and Brooklander Bijan C. Bayne credits Turkey Thicket as a major factor in the high concentration of college and professional basketball players from the area.

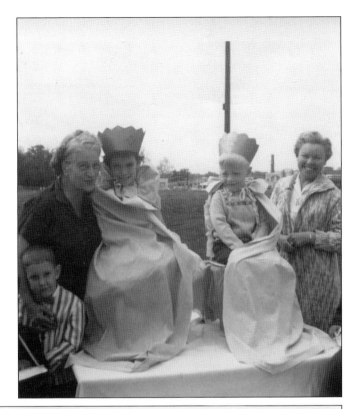

Stanley's Five-and-Dime was located at 3520 Twelfth Street. It was an independent notions store that carried office supplies, household goods, toys, candy, and seasonal items. Valentine's Day was memorable. Stanley's had a wide selection of lace paper hearts and inexpensive gifts for valentines. The manager of Stanley's was proud of his restraint in decorating for Christmas—always waiting until at least a week after Thanksgiving.

Campus School, also called the Model School, was founded in the 1930s by Fr. Thomas Shields, the champion of the Sisters' College. He envisioned it as a lab school, where advanced techniques in elementary education would be tested. It was beside the Sisters College on the 900 block of Varnum Street and an easy walk. Descendants of the Brooks family, such as Mary Stock Kelly's children, attended Campus School, as did CUA faculty children. (CUAA.)

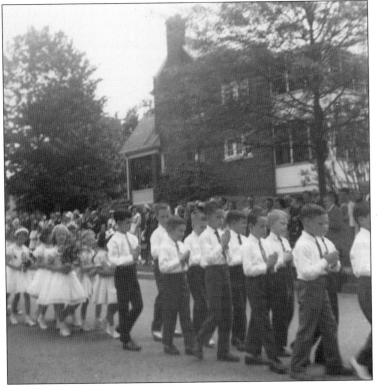

The first day of May brought May processions to Brookland. Some families made a Mary altar at home. Children brought mock orange, bridal wreath, and hyacinths to school to decorate altars in their classrooms. On the first Saturday, the Campus School community came to Varnum Street and processed to the circle in front of Brady Hall, on the Sisters College campus, to crown the statue of Our Lady of Wisdom.

Brooklander Martin D. Jenkins (right, foreground) received his education degree in 1931, from Indiana State University. He and his wife, Elizabeth Lacy, then moved to Chicago where Jenkins earned his master's degree and doctorate in education from Northwestern University in 1938. After earning his doctorate, he joined Howard University's education faculty and taught there until he became president of Morgan State University in Baltimore. He is shown with Ralph Bunche (center) at a Morgan State University commencement. (AAA.)

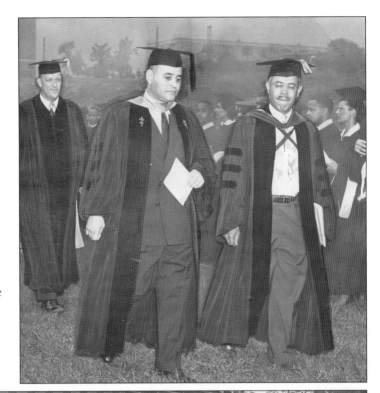

Martin D. Jenkins (right) accepted a faculty position at Howard University, where he taught from 1938 until 1948. Even when Jenkins became the president of Morgan State University, he and his family continued to live in Brookland. His home and this lovely patio, his Howard University–affiliated neighbors, and Brookland's quiet, almost rural character in the 1950s, all may have influenced his decision to stay. (AAA.)

Patricia Roberts Harris served as Secretary of Housing and Urban Development under President Carter. She was the first African American woman to hold two cabinet-level positions when she became Secretary of Health, Education, and Welfare. She became the first female African American ambassador (serving in Luxemburg), under President Johnson. Harris lived at 2802 Thirteenth Street** from 1958 to 1965. She was an officer for the Brookland Civic Association and, in 1982, ran for mayor. She is buried nearby at Rock Creek Cemetery. (DCPLW.)

Jimmy Neville, the son of Anne Fitzpatrick Neville, the girl who looked so directly into the camera in the 1938 St. Anthony's cornerstone laying (page 83), assists as a flag bearer in 1965. Behind him is Cub Master Posey Keller (center). Keller oversaw an integrated Pack 98 for many years. While the pack was integrated, the dens usually were not in the 1950s and 1960s.

Jean Kerr met her husband, Walter, while he was teaching at CUA drama department. He went on to become the drama critic at the *New York Times*. She went on to write the book *Please, Don't Eat the Daisies!* and the play *Mary, Mary*. During their Brookland years, they lived at 1001 Varnum Street. (Associated Press.)

Lorraine Hansberry stayed with the Wood family, at 1304 Newton Street, when she came to Washington. Her best-known works as a playwright are *A Raisin in the Sun* and *The Sign in Sidney Brustein's Window*. She was the first woman to have her work produced on Broadway and the youngest to receive the New York Drama Critics' Award. She died of cancer at the age of 34 in 1965. (AAA.)

In 1959, John Carroll High School won the city championship against Cardoza, 79-52. This dream team (with 55 straight wins) was led by future NBA player and Georgetown coach John Thompson, George Leftwich, who would later coach at the University of the District of Columbia (UDC) and Carroll High. Also on the team were Tom Hoover, who played for the NBA and the ABA; and Monk Molloy, who became a priest and president of Notre Dame. (George Leftwich.)

The senior varsity players of St. Anthony's High School in 1975 were all girls from the neighborhood. Pictured from left to right are D. Chase, R. McElrath, L. Lightfoot, Maureen Daley, and D. Anglin. CYO player not pictured is Brooklander Cheryl Armstrong, whose father, McKinley Armstrong, coached athletes at McKinley High School (no relation), including many players who went on to professional sports careers. Maureen Daley is the daughter of Bill "Bulldog" Daley, who coached CYO girls' sports for many years. He was also the head of the speech pathology department at the CUA.

Here is the interior of St. Anthony's in 1960. The mural of the saints seated on clouds, with Mary above, was mass-produced on canvas and secured to the wall; it has since been removed. (SAA.)

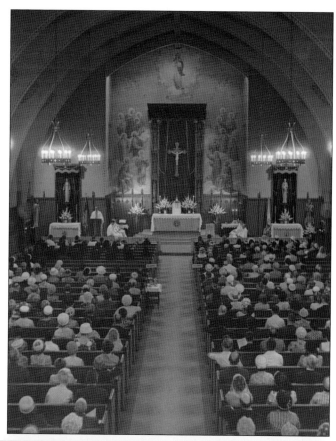

In 1966, Fr. John Bailey celebrated his 25th anniversary in the priesthood. To celebrate a number of events were planned at St. Anthony's, including a mass, followed by a dinner, and a concert in the high school gym. Playing the piano is Bea Wilkinson, mother of five and wife of deacon, Larry Wilkinson. Father Bailey is in the center of the front row. (SAA.)

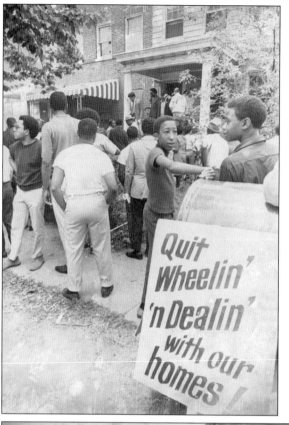

From the mid-1960s until 1977, there was great resident opposition to the building of the North Central freeway, which would have put Interstate 95 through Brookland, and would have resulted in the loss of 350 houses, mostly along the railroad tracks. A coalition of activists fought this plan: Brookland Civic Association president Bernard W. Pryor; CUA art professor Thomas Rooney; Angela Rooney; Fred Heutte; future mayor of Takoma Park Sam Abbott; and activist Floyd Agostinelli. They opened a boarded-up house on the 3400 block of Ninth Street Northeast that was slated for demolition and began to renovate it, resulting in their arrest. Some of the public hearings at the DC city council became quite heated (below). Ultimately, the funding for the North Central Freeway was diverted for subway construction, but 69 row houses south of Lawrence Street and along the tracks were already torn down and were not replaced. (Both, DCPLW.)

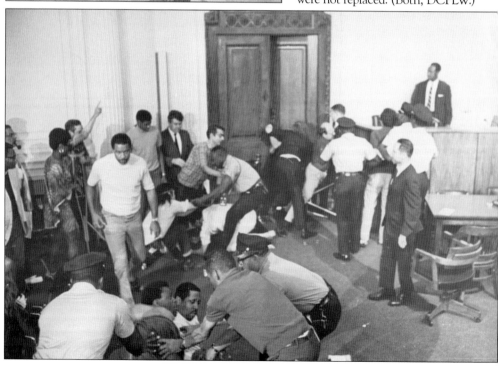

St. Anthony's had a high school since 1928 but did not have its own building until 1964. Many parish events were required to raise the funds for a building that would include a gym, science labs, and a large cafeteria. St. Anthony's had the distinction of being one of the two coed programs in the diocese. (SAA.)

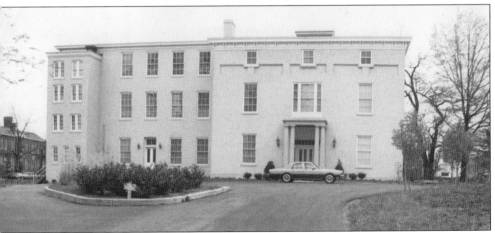

The Brooks Mansion had been the Benedictine Sisters convent for many years when Father Bailey of St. Anthony's sold it to the Metropolitan Transit Corporation. Metro considered demolishing it and building a parking garage there. Neighborhood residents worked, instead, to have it listed in the National Register of Historic Places in 1982, barring any change to its facade. (CUAA.)

Barbara Lett Simmons (standing at left), later a school board member, speaks at a community meeting in the 1970s; she is talking about the old Brookland School. The building was in disrepair, and the community wanted a way to use it. Shortly afterwards, the DC Street Academy moved into this historic structure. Now, the Luke C. Moore Academy offers a GED program for adult students. (DCPLW.)

Here is Frances Leola Carter (also pictured on page 107) teaching at Trinity College in the 1970s. Trinity began offering a broader scope of programs in these years, including concentrated courses with all-day Saturday classes for working professionals. Public school teachers, especially, began to take advantage of this program. Under the leadership of President McGuire, it became a university with coed programs and an extended mission to women of color into the 21st century. (TUA.)

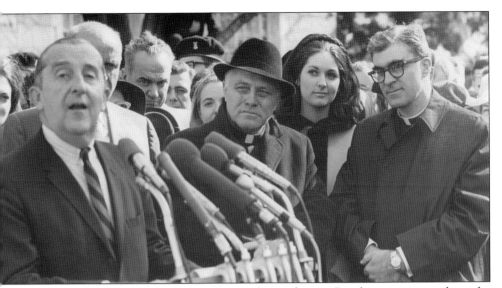

r. Gilbert Hartke, center, listens as Richard Coe, the *Washington Post* drama critic, speaks at the ornerstone laying of the Hartke Theater at CUA. The crowd includes Linda Johnson Robb. The arrival f Hartke Theater to the Brookland scene ushered in years of excellent theater in the neighborhood. Helen Hayes offered her last stage performance there. Dublin's renowned Abbey Theater performed here in 1976. Donald Waters, CUA drama professor and Brookland resident, is shown behind and o the left of Father Hartke. (CUAA.)

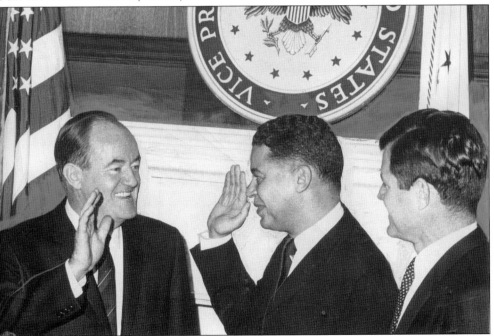

Republican Sen. Edward Brooke (center) is sworn in by Hubert Humphrey in 1967, with Ted Kennedy t his right. Brooke's parents moved to 1262 Hamlin Street while he was at Howard University. In ater years, his mother said she always thought of Brookland as home. Brooke joined her here after his divorce. He was the first African American to be elected to the US Senate since the Reconstruction ra and served for 12 years. (AAA.)

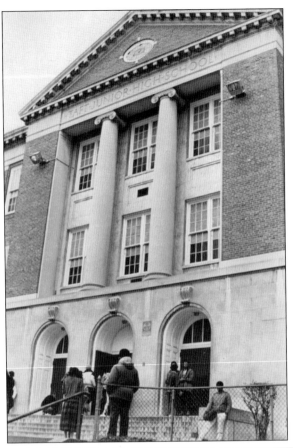

Taft Junior High School appears in the 1970s. Integration in the public schools brought better facilities for all students, but did not bring integration in Brookland. Just as some church congregations became predominantly black in the 1950s and 1960s, so did schools. The Catholic high schools, including Archbishop John Carroll, St. Anthony's, and St. Anselm's Abbey School, integrated gradually, but white families largely left the public schools of Brookland. (SSMA-HW.)

Angie Corley stands on the front lawn of her 3519 Fourteenth Street home, with two of her children. The farmhouse where Robert Weaver was born (in 1907) and raised once stood on this site. Corley was president of the Advisory Neighborhood Commission 5A and was the Ward 5 representative on the school board. She and her husband, Andrew, an attorney, have been lifelong Brooklanders. (GWA-GM.)

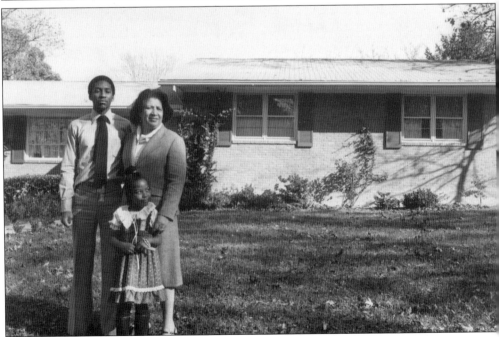

Longtime Brookland resident Phil Raidt attended CUA and established the Fine Arts Council while there in the 1970s. The council sponsored programs open to all Brooklanders, including weekly films, lectures, and festival events on campus, and art and foreign films at the Newton Theater. The council also sponsored a well-remembered fall festival held on St. Thomas Hill on CUA's campus. (CUAA.)

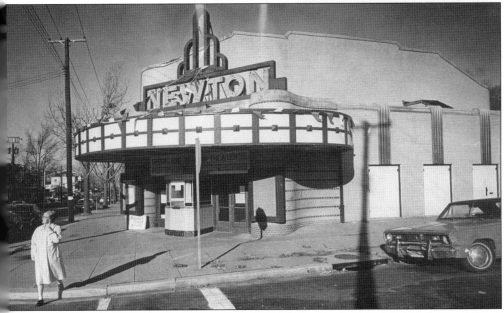

Newton Theater was built in 1937 by Jesse Sherwood. The architect was John J. Zink. The original Brookland Baptist Church had been on this site. The neighborhood movie theater had a unique place in the community before television. But by the 1970s, the Newton was failing. It continued as a cooperative venture for a few years, and the CUA music department used it as a rehearsal and performance space. The building was designated as a DC historic landmark in 2009. (DCPLW.)

This is the Jesse Theater, near the intersection of Rhode Island Avenue and Eighteenth Street. It is at the eastern end of the Sherwood addition to Brookland. Jesse Sherwood built this theater in 1927. In the 1960s, it became the Stanton Art Theater. At first, it showed foreign films, but in later years, it became an adult movie venue. It closed in the late 1970s. Today, a congregation is converting it into a church. (HSKP.)

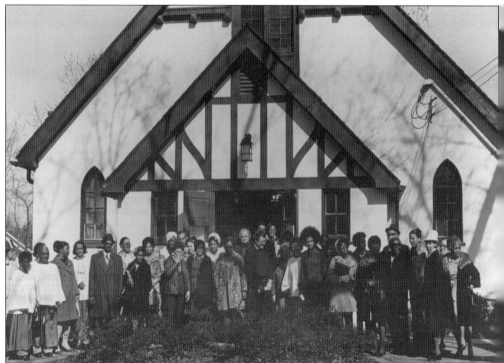

Members of the Church of Our Savior at 1616 Irving Street gathered at its doorway in the 1970s. Unlike some other churches, this congregation never left its home church, which was founded in 1892. This church building dates to 1897. (Jim Steigman; photographer Lillian O'Connell.)

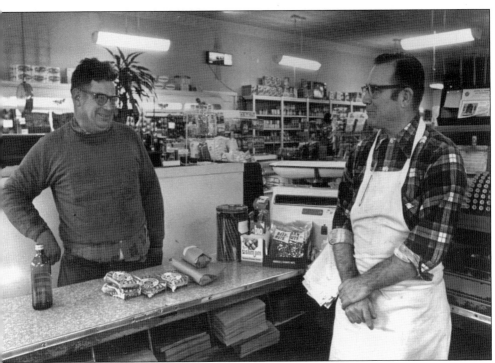

The MPM market was the old-fashioned grocer in Brookland from the 1950s to the early 1980s when it closed. It had a butcher and a produce clerk who were attentive to customer requests. In 1981, the Safeway at 12th and Quincy Streets closed. In response, the new Brookland Co-op organized a farmers market in the parking lot that joined St. Anthony's and DC Street Academy. That turned into a buying club operating out of the back of Stanley's Five-and-Dime. Then, they sponsored a seasonal farmers market under the Charles Drew Bridge (Michigan Avenue Bridge), where there is one again today. The co-op eventually opened a market in the old Safeway but closed due to financial problems in 1992. "Yes! Organic Market" opened in 2007, in the old Safeway, bringing a large food market back to 12th Street. (Jim Stegman, photograph by Lillian O'Connell.)

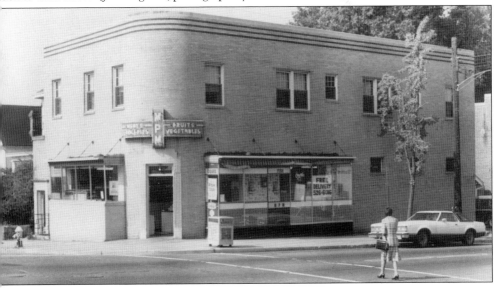

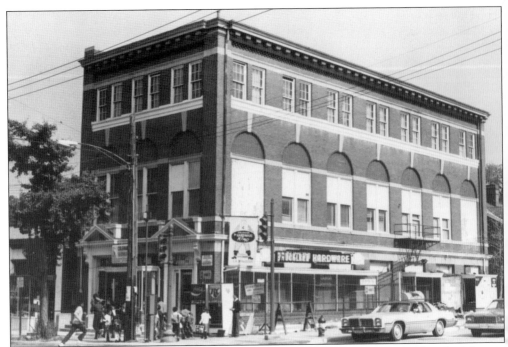

Brookland Hardware has been a focal point on Twelfth Street for decades. Located in the Masonic lodge—still the tallest building in central Brookland—the store is jam-packed with items and advice. Upstairs, the Masons continue to practice the rites of their order. In the 1960s, the King David Lodge transferred the hall to the St. John's Lodge, an African American assembly, affiliated with the traditionally black Prince Hall Lodge. (GWA-GM.)

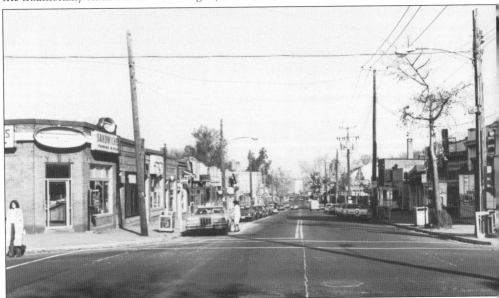

The buildings on Twelfth Street have changed little since the 1920s. The establishments have changed names but are often in the same line of business. The Library Bar was Johnny K's, and before that Kitty Oshea's, CU at Pete's, Fred's Inn, and, at its inception, Hap's. Northeast Tae Kwon Doe was Stanley's Five-and-Dime. The Coin Op Laundry was Baldwin's Bakery. (GWA-GM.)

This picture shows two boys from the St. Joseph's Orphanage (now the Missionaries of Charity Hospice) with their baptismal sponsors. John J. Feeley, Sr. is on the right. The lady on the left is Velma Johnson, who with her husband, Bill, purchased six buildings over time on the west side of the 3600 block of 12th Street. There they established businesses and rented properties. They also founded a college scholarship fund for needy DC high school students. The 3610 Boutique was their first property.

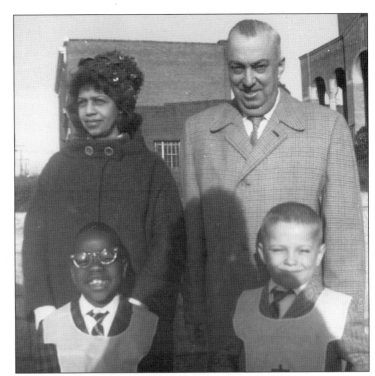

Northeast Community Festival was one of the many events used to mobilize the neighborhood in the Interstate 95 "Freeway Fight." Speakers called for continued lobbying against the federal plans for Brookland. The controversy also led to strong support for statehood of the district. Maureen Nichols, of the 1300 block of Newton Street, is in the left foreground, looking at the camera. Later, the Brookland Festival and Festival of Lights would become annual events.

Brooklanders take their protest message to the White House with a banner made by Fred Heutte (left, holding the banner), a statehood supporter and the party candidate for the city council in the 1980s. The banner appeared at many anti-freeway rallies and pro-statehood demonstrations. Fred and his wife, Anne, moved to Brookland in the late 1940s because it was an integrated neighborhood. Fred led the choir at St. Anthony's for many decades. (DCPLW.)

Thomas Wyatt Turner remained loyal to the Roman Catholic church throughout his life. He taught at Howard University for a decade, and late in life, he lived with his family in Brookland. In 1976, the Catholic University of America awarded 99-year-old Turner a degree. This was a great satisfaction for Professor Turner, as he had been denied entrance to the school because of his race in 1917. (CUAA.)

In the 1970s, woods surrounded most of the institutional properties in Brookland. Some CUA students are pictured going to class through the woods. The undeveloped parcel of university property, located along Taylor Street, is notable for having been set aside by the university as a botanical preserve at the time of its founding. Many varieties of shrubs and plants not generally found in Brookland are found in this ravine. (CUAA.)

In 2006, CUA purchased 49 acres from the Armed Forces Retirement Home. This view shows the Shrine of the Immaculate Conception through that wooded site. While there has been much recent conversation on development in Brookland over the last few years, it is good to consider how much Brookland still has of its open spaces and historic landmarks. (Photographer Benita Bing.)

www.arcadiapublishing.com

Discover books about the town where you grew up, the cities where your friends and families live, the town where your parents met, or even that retirement spot you've been dreaming about. Our Web site provides history lovers with exclusive deals, advanced notification about new titles, e-mail alerts of author events, and much more.

MADE IN THE USA

Arcadia Publishing, the leading local history publisher in the United States, is committed to making history accessible and meaningful through publishing books that celebrate and preserve the heritage of America's people and places. Consistent with our mission to preserve history on a local level, this book was printed in South Carolina on American-made paper and manufactured entirely in the United States.

This book carries the accredited Forest Stewardship Council (FSC) label and is printed on 100 percent FSC-certified paper. Products carrying the FSC label are independently certified to assure consumers that they come from forests that are managed to meet the social, economic, and ecological needs of present and future generations.

FSC
Mixed Sources
Product group from well-managed
forests and other controlled sources

Cert no. SW-COC-001530
www.fsc.org
© 1996 Forest Stewardship Council

Find Your Place in History.